Parenting Tough Kids

Simple Proven Strategies to Help Kids Succeed

Mark Le Messurier

Skyhorse Publishing

Visit our website at www.skyhorsepublishing.com.

10 9 8 7 6 5 4 3 2 1

Library of Congress Cataloging-in-Publication Data is available on file.

Cover design by Caroline Schrader

Print ISBN: 978-1-62914-775-8
Ebook ISBN: 978-1-63220-084-6

Printed in China

Table of Contents

About the Author – Mark Le Messurier

Mark Le Messurier is a teacher, author and national conference presenter. He also is the recipient of the prestigious National Excellence in Teaching Award.

Parenting Tough Kids is his third book, but it is the first written exclusively for parents.

Mark's second book, *Cognitive Behavioral Training: A How-to Guide for Successful Behavior*, was written for special education coordinators, teachers, teachers in training, school support staff, counselors, psychologists and health care professionals. This best-selling, practical resource addresses common problems that many students face regarding organization, remembering, self-awareness, motivation and emotional resilience.

Mark also has produced *Reflections on Dyslexia,* which is a teacher training and development film about dyslexia and ADHD (Attention Deficit Hyperactivity Disorder).

In 2000, Mark coauthored a book and DVD titled *STOP & THINK Friendship*. This resource was revised in 2002 and is currently published as *Friendship Neighbourhood: STOP and THINK Workbook.*

In 2006, the South Australian Catholic Behavior Education Team approached Mark to design and coordinate a mentoring program for their teachers. The program provides opportunities for teachers to develop skills for mentoring students who are experiencing learning, social or behavioral problems. These students, whose ages range from 6 to 18, are often the "tough kids," who can benefit substantially from ongoing friendship and encouragement from a caring adult working within the school system. Mark describes the program as "truly inspirational" and will tell you what a privilege it is to work alongside such passionate teachers and educational support staff. In a very short time, a number of highly skilled school personnel were able to begin taking extra care of some of the most vulnerable students in the schools. The hope is that gradually more and more at-risk students will be supported by the amazing ripples that are beginning to radiate from this uplifting program.

Most days, Mark can be found working in his private practice at Fullarton House in Adelaide, South Australia. There, he provides counseling, mentoring, educational advice, academic remediation and social skills training for children and teens. Mark's work focuses on strengthening the success of students often identified with learning issues, behavioral difficulties and personality disorders. His background encompasses 20 years in the classroom, which included

special education, adult education, child-centered education and community education projects. It is easy to see why Mark received the prestigious National Excellence in Teaching Award.

Contact information:
www.marklemessurier.com.au
Email: *lemess@ozemail.com.au*
Tel: (08) 8271 2899
FAX: (08) 8373 7018

Acknowledgements

In recent years, my work has thrust me into the lives of countless families, and I've been inspired by the resourcefulness of so many parents. Often they manage the challenging behaviors of their children fabulously well. Their collective wisdom has contributed greatly to the ideas presented in this book.

My gratitude also extends to my wife, Sharon, and my colleagues at Fullarton House, whose gentle interest buoyed my perseverance. Thank you Rose, John, Madhavi, Benita, Jane and Jenni for helping out with the editing. Your ideas, opinions and input were so appreciated.

My final acknowledgement is to Peggy Hammeken. Thank you for your confidence, sharing of resources and investment in this project, Peggy. Your help is invaluable in disseminating this information in the U.S. and internationally for the benefit of parents and educators.

Chapter 1

The Challenge of Parenting Tough Kids

For most parents, raising children is hard work. For some, the struggle with one child, or all of their children, threatens the family's cohesion. Children with challenges of one kind or another can, in turn, present great challenges for their parents. This book is meant to help alleviate many difficulties with practical, specific strategies to help children improve behavior and learning and develop emotional resilience and friendships. Then, the challenge of parenthood is compensated by the joy and satisfaction parents receive as their children emerge successfully into the world

To begin with, parenting skills are hugely more intricate than they may seem to be and involve much more than just knowing what to do. There is a fine line between parents who know the answers and those who know the answers and can also put the skills into action, even under pressure. When under pressure, most parents admit they succumb to the obvious parenting pitfalls, even though they know all about them. They blame their runaway emotions, which are driven by their deep love for their children.

So often, parents know they teeter between expecting too much or too little, or they find themselves interfering with their children's decisions with too much helpful advice. They do this because they hope it will help their children become more responsible, meet expectations, increase friendships or improve their school grades. They also may be trying to improve family harmony. Eventually, most parents discover the elusive balance needed between saying and doing too little for their children and saying and doing too much. They discover they don't have to have all the answers, because the harder they work at finding them, the more likely they are to limit their children's independent emergence into the world. All children need to engage with the world, experience problems, feel discomfort, find solutions and experience the good and not so good outcomes of their actions and decisions in order to develop robust and resilient emotional resources.

Poor parenting methods and family tensions certainly contribute to difficulties, but they are not the only causes. Many children just learn the hard way, or in a different way, so a thoughtful, consistent approach at home truly makes a difference. The difficulty for these children is more often in their own natures or styles. They may experience problems with memory, persistence, emotion or organization, and each of these difficulties can heavily impact their day-to-day functioning. Parents need to know this. In particular, the early teenage years can be a period of powerful control struggles. Developmentally, we expect children to flex their teen spirit for greater control, yet when it happens, the intense flashes of independence and defiance catch many parents off guard. For some, this can become a protracted adventure, in which adolescents take their families emotionally captive along the way.

At whatever level of difficulty, tackling these issues can be overwhelming. It is not a matter of unearthing a miraculous cure. Simply start by looking at yourself, your child's temperament and your family, and figure out what is really happening at home. Let's begin.

What do you see when you look at your child?

Parents often believe that a good intervention should work, and work fast—just like a headache cure! So when a sensible intervention does not provide fast results, the assumption often is that the intervention did not work. It is more effective to accept the fact that progress is slower for some children, and especially for those with learning difficulties, emotional problems and developmental delays. It is our simple, daily actions and attitudes that will make the greatest difference in our children's development and happiness.

Without this clear-headed awareness, it's all too common to see parents jump on the professional merry-go-round when problems occur. Often parents first seek a diagnosis for the child from a psychologist or health care professional. This sensible beginning sharpens the parents' understanding of the difficulty and available interventions and can refine management of the issue. Then, the process can get out of control. The quest to find the cure intensifies with seemingly harmless and hopefully helpful visits to experts. These might include counselors, therapists, special learning centers, occupational therapists, social skills trainers, language therapists, speech pathologists, educational tutors, physiotherapists, chiropractors, naturopaths, dieticians, hypnotists, acupuncturists and others.

In this situation, it is the child who often loses. This result is perfectly illustrated in the following anecdote.

It was the first time I had met 10-year-old Max and his mom, Cate. I had set aside an hour for the appointment and spent the first 40 minutes listening to Max's mom explain his difficulties. Once Cate finished, I walked with her from my room and brought Max in from the waiting room.

As we sat down, I smiled at Max, and he flashed an accepting smile back. I asked if he would mind waiting for just a moment while I finished writing a few notes. He smiled again and said that he didn't mind.

While I was writing, Max quietly asked, "How sick am I?"

"You're not sick at all, Max," I answered. "What makes you ask that?"

"I must be," he said, "because Mom takes me everywhere so someone can make me better."

Max's comment is a reminder that when children are carted from one professional to another for too long, they can easily develop an 'in therapy' attitude about themselves. Excessively long or intense intervention delivers a message to children that something must be seriously wrong. It reinforces the idea that someone else or some new slick program will take responsibility for their difficulties and will fix their lives. A better approach is one that consciously builds the emotional strength of children. (For practical suggestions on how to build your child's emotional strength, see the final chapter of this book.) It is most effective to adopt thoughtful approaches to building friendships, setting goals, negotiating clear expectations, targeting academic remediation from time to time, coordinating curriculum adjustments at school and appreciating the unique attributes of your children.

Challenge yourself:

Naturally, many parents of a child with difficulties live in heightened states of worry about the child's accomplishments and prospects. Your challenge is to think about what you feel and see when you look at your child.

Do you feel fear, despair, disappointment, annoyance or joy?

Do you see too many problems?

Do you look too intensely and critically and feel entangled in your own emotions?

Do the problems you see overshadow your child's strengths, uniqueness and potential?

Sometimes when a parent has long been absorbed in the child's difficulties, objectivity and a sense of humor can become casualties. Many children will remain dependent on poised, intelligent adult input and reliable family structure for a long time, so make a promise to yourself today. Start to see your child more favorably. Promise to prioritize what should be tackled, and inspire your child to participate in his or her own life. Start by inviting the child's opinion on ways to capitalize on strengths and find greater success in life. And keep that sense of humor! It will help your child to develop one too, which is a tremendous advantage.

Challenge yourself:

Ask your child . . .

"What do you want me to do to help you?"

"What can you do to feel more successful?"

"How can we work on this together so that you become 'the boss' of your life?"

What is happening in your family?

Think about each of your children's lives and how each child fits into the family dynamic. How does each child fit in? What helps and what hurts? We have long known that each of our children consciously and subconsciously take on a role in the family based on what the child sees is available. A child may choose a helpless role or become a clown or a complainer. Another child may become very responsible, because at some point he became convinced that this role would provide him with status, power and reward. The role each of your children has chosen is often a result of the family structure and the style of interaction that has developed.

Some situations support children in feeling resilient and buoyant and wanting to cooperate. Other situations unsettle, provoke poor behavior, poor attitudes, poor organization and poor motivation. As uncomfortable as it may be, ask yourself the following questions:

- Is your family battling with marriage problems?
- Are you burdened by financial difficulties, or religious or racial issues?
- Has your family recently moved to a new home?
- Are your children about to enroll in a new school?
- Is your family experiencing on-going anger or violence or experiencing a death and/or illness?

These are just a few of the pressures families can experience, and each is capable of making a big impact on what is happening with the children.

What is the size and composition of your family?

Do you know your family's natural limitations and potentials? Families are wonderfully diverse. Some children live with grandparents, or grandparents live with them. Other children live in single-parent families, blended families, divorced families or families that have foster or adopted children—maybe those children themselves. Some families are small, whereas others are very large. The age span within each family is another dimension. I often remark affectionately to parents who have three children under the age of eight, that while there is much they can do to support each child's development and success, it is probably one of the most demanding times they are likely to face as parents. Certainly, the size and composition of each family brings forth a unique set of issues. The form of your family alerts you to its natural limitations and also how you can best bring out its potential. This, in itself, is a good starting point!

What is it like living in your family?

Does your family run like a well-oiled machine, or is it chaotic? Some parents are able to run their households like clockwork. They set times to tackle tasks, expectations about how they will be tackled and how long the tasks will take. Sometimes this approach works very well. However, strict expectations that constantly highlight the difference between what is expected of a child and what the child is able to deliver usually result in failure. In these situations, children can become so resentful that they rebel and sabotage the system to vent their frustrations.

At the other end of the continuum are households that are too busy and constantly run on empty. These families cram too much into their lives. They are often noisy, and the frantic pace is fueled by hi-octane emotion. We see parents trying to meet extraordinary work pressures and attempting to meet unrealistic deadlines, while making daily dashes across the city to drop their children off at various sporting events or recreational activities—often arriving late. The distinction between being busy and living in chaos becomes completely blurred. Family routines and personal composure become casualties, contributing greatly to general frustration and irritability.

What is really important?

As parents, we need to reassess whether our values and expectations concerning our parenting are working for us, our children and our families. We need to be sure we are not hanging on to outdated approaches and also to avoid stereotyping our children. Labeling them as The Click and Go Generation or The X Generation immediately distances them from us. Stereotypes can be limiting and damaging, and before we know it, we're likely to hear ourselves mouthing the age-old complaints that our youth have bad manners, hold authority in contempt and don't show respect for us. To be honest, most of us gave our parents some trouble, and in most cases, we were not remarkably better behaved and more obedient than our own children, nor did we hold our parents in higher regard than our children hold us in today. Children will generally live up to our expectations. If we make it clear that we expect them to behave well and be respectful, and if we model that kind of behavior for them, we are much more likely to see positive results.

What will your role be in your child's success?

Success is not achieved with smoke, mirrors and magic. Nor is it necessarily achieved by simply enrolling your child in an expensive private school. It is accomplished through planning, persistence and definite commitment.

We have long known that successful individuals, with or without difficulties, have not become successful by accident. Over the years, numerous studies have concluded that immersing young people in positive, encouraging, 'can-do' environments, at school and at home, is what makes the difference. Often, it is simply adults with 'you-can-do-it' approaches operating in positive, structured environments that promote 'I-can-do-it' attitudes in young people.

The latest brain research has revealed that new learning actually causes increased brain density and weight! The brain is a dynamic organ capable of changing, growing stronger and making new connections with use. This flies in the face of the traditional view that each of us is born with an IQ virtually set in stone and that this IQ is what makes or breaks success. Knowing that the brain continues to develop through feeling, thinking, choosing and reflecting should make a world of difference to a parent's approach and a child's optimism.

Emphasize to your children that the brain is like a muscle. The more they use their brains, the more successfully their brains will work. Every time they think, their brains will make new connections, and this will increase memory and learning. Striving to learn something new every day, persisting at tasks, reflecting on social encounters, thinking about choices and trying new things will, over time, boost your son's or daughter's potential for success. Therefore, the next

time you say, "Keep trying, darling. That's how you'll get smarter and succeed," remember that scientific evidence now supports you.

What do you offer in your home?

Unless we acknowledge the depth of our family resources, the positive influences we are able to generate for our children will likely be erratic. Before leaping into plans that encourage your children to increase their organization, care, motivation or responsibility, take a look at your personal and family resources. Doing this helps to reduce the temptation to blame children for their under-performance. To be successful, children need the most important people in their lives--their parents--to develop a family structure and a way of life that sets them up for success.

Take a look at a few guiding ideas on how to help children become successful. Reflect and compare with what is happening now in your family.

Do you offer acceptance and positive attitudes?

A home environment of acceptance, care and good humor allows the fine-tuning of behaviors. On the other hand, an atmosphere of criticism and resentment promotes pure opposition, and even hatred.

Work at loving your children for their differences. Their quirkiness may well prove to be their best asset in the future. And, if the difference is a genuine part of a child's individuality, what messages do you send if you constantly criticize the child's efforts and style? It may be your salvation to keep in mind the saying "You can't change the wind, but you can adjust the sails."

It's often said that the best way to encourage positive behavior is to catch children doing well and comment on it. Aim to have your positive comments outweigh negative remarks by 10:1. If you find it difficult to say something pleasant, then say nothing, and be careful not to dress up criticism in a sugary way with a strained smile. Of course there is a place for constructive criticism. However, the timing needs to be right and your emotions need to be in check. Otherwise, it's too easy to rant instead of dealing with the behavior.

To help maintain family buoyancy, have you considered introducing a positive saying to the family each week? A multitude of sayings are available, such as:

"Don't wait for your ship to come in; row out and meet it."
"A diamond is a piece of coal that has stuck to the job."
"If you can't have what you like, like what you have!"

These short sayings can be influential, and the edge they can provide is surprising. The best sources for quotes are inexpensive, inspiring books often on sale at the local bookstore. You also might try the Internet.

Challenge yourself:

What did you say to praise each of your children today?

Have you told each child that you love them today?

If not, can you change that right now, later at mealtime or before they go to bed tonight?

Do you offer healthy relationships?

Loving relationships count for so much, and healthy relationships are even more important when you are attempting to support your child in changing and developing new behaviors and routines. Arrange enjoyable experiences for each child. The release of endorphins, our body's powerful feel-good chemicals, at these times is sure to strengthen your bond with your child.

Go out for an ice cream sundae, go shopping, play a game, or go for a drive and talk. Head out to the movies, have a picnic, visit your child's favorite place, walk to the playground, rent a video and watch it together, or begin a special project. At the very least, schedule something once a month, so each child is guaranteed some special one-on-one time. The aim is for each of your children to know that you look forward to doing this one thing alone with them. It becomes their special time with you! Time, used well, provides the opportunity to build healthy, long-lasting, loving memories for children to hold. Without quality relationships, whatever we decide to put in place will be little more than a collection of behavioral modification tricks resulting in temporary controls, at best.

Challenge yourself:

How long has it been since you spent special alone time with each of your children?

Can each child identify what you do that is special for that child?

Mentally list what you can start doing.

Do you allow each other to parent?

The good news is that parents can manage children differently and successfully. What does not serve children well is when parents continually bicker between one another over who parents best. A huge setback occurs when parents begin to compensate for the inadequacy they see in

their partner's style. As a result, each parent chooses a compensating style. One may chill out and be overly relaxed in the belief that he or she is successfully compensating for a partner's intense, overly critical approach. Rather than creating balance, this interplay creates friction. The children in these families quickly learn that there is so much tension between their parents that it is easy to play them against one another to get around expectations and get what they want. When one parent picks up on something (e.g., chastising, ignoring a behavior or giving a consequence), then it is best to allow that parent to make the call and follow it through without hindrance. In doing so, parents avoid power struggles between each other and set the scene for much clearer communication with their children.

Challenge yourself:

Have you used the same old words with your partner over managing or disciplining the children this week?

Does this get in your way?

Start talking openly together and find ways to minimize the problem.

Does dad offer 'father-time' with the boys?

At long last, the profound influence fathers have on their boys is acknowledged. Every newly released study and every contemporary expert concerning the relationships between fathers and sons tell us that the quantity and quality of this relationship is pivotal to the sort of young man that will emerge. Dr. Peter West explores the relationship between fathers and sons in his book *Fathers, Sons and Lovers*. He interviews men who talk freely about being boys and how their relationships with their fathers impacted their becoming men. This quote says it all:

"These men each acknowledge that their father is an important person in their lives. Above all, the father sets the model of how the son is to behave. And the son has to live with that. He can conform to it, or rebel against it. Either way, a father puts his stamp on a son's life." (West, 1996, p. 82)

The following narrative also helps to illustrate the impact a father has on his son, even though it may not be apparent at the time.

Don, the father of a fourteen-year-old boy, asked his son if he'd like to go camping and rock climbing for a few days during the upcoming holidays. Will's response was, "Not really," because there'd be no cell phone reception and it would probably rain anyway. To Don's credit, he quietly persisted and they went camping together. Subsequently, Don told me he thought Will had enjoyed himself, although he managed to

complain about being out of cell phone range, not having the right breakfast cereal and so on. When I caught up with Will, there was no stopping him from telling me about every moment of their trip! He had loved the experience with his dad. I also worked with several teenagers who are friends with Will, and in the days that followed the camping trip, they each talked about Will and Don's adventure as something that was "just awesome."

Challenge yourself:

Dad, what are you doing to develop your relationship with your son?

What did you do this week?

When was the last time you went away together?

Start planning now!

Do you keep the 'big picture' in sight?

As you sense an impasse developing, be flexible and draw on creative ways to deal with it. Think about whether you are facing a hiccup, a difficulty or a crisis. Should it be deflected with wit, ignored or dealt with?

The wisdom of hindsight tells us that many things do not need to be dealt with. Avoid being drawn into the small issues. It is too easy to be drawn into negative and demanding ways. It may help to make a list of the annoying behaviors you see in your son or daughter. Trade lists with your partner. This makes for an entertaining discussion and helps to steady the 'big picture' for both parents. This process helps to clarify what is important by aligning your attitudes. It is vital from time to time to take stock and agree on the things that need to be dealt with and the others that can be let go. Maintaining a big-picture understanding is a terrific investment towards achieving the sort of young man or woman you want in the future.

Challenge yourself:

How long since you have traded lists with each other to highlight things to be ignored and things worth tackling?

Come on; stop reading and make a list. Ask your partner to make one.

Trade the lists, and start talking about the similarities and differences.

Are you a parent with a backbone?

A wonderful freedom emerges for parents when they are able to implement expectations, boundaries and rules with their children.

The opposing situation is the mom or dad who lives with the uncertainty of how to keep the children as their 'best friends' when tricky circumstances crop up. Instead of fearing being bad friends to their children, parents who have developed the art of leadership, negotiation and compromise put themselves as well as their children in the best position. Barbara Coloroso, author of the international best seller *kids are worth it!* categorizes three kinds of families created by parents. They are the "brick-wall," the "jellyfish" and the "backbone" families. In a brick-wall family, the structure is inflexible and often used for control and power by the parents. A jellyfish family has no firm parts, and this family reacts to every event that comes its way. Not surprisingly, a jellyfish family faces far more catastrophes than most families. On the other hand, backbone families are firm, flexible and functional, and a structure is always present.

Challenge yourself:

Describe your family structure.

Who has the power and control?

Is this what you want?

Do you control, guide or want to be one of the gang?

Is your structure working?

Is it sustainable?

Do you offer adequate diet, exercise and sleep to your children?

Most adults can pick the children who have not had enough sleep, have not had breakfast and have had a soft drink and a chocolate bar for their morning break. Their mood swings, erratic behavior and poor concentration tell all. The effects of certain foods, sugar, preservatives and food colorings on individuals are now well documented. Breakfast remains the most important meal of the day, and naturally some breakfast foods are better than others. Protein foods (milk, cheese, yogurt, soy products, white meat and eggs) are a major source of amino acids, and these are thought to produce the neurochemicals involved in learning, socializing and decision-making.

At least once a day, for 10 to 20 minutes, ensure that your children get outside for some fun and aerobic exercise. Not only does vigorous exercise burn off excess energy, but getting the mandatory 10 minutes worth of sunshine provides an essential dose of vitamin D. The fun factor helps release endorphins, and these help to ensure happiness—a priceless commodity!

In addition to a good diet and adequate exercise, the importance of sleep to a child's effective functioning has been well documented. In *Creating Balance in Children's Lives: A Natural Approach to Learning and Behavior,* Dr. Lorraine Moore writes, "Sleep and rest play a significant role in the body's biological, learning, and emotional processes. Sleep is needed to provide support for growth and development, to restore the body's tissues, and to provide the conditions necessary for consolidating and integrating new learning and memories." (Moore and Henrikson, 2005, p. 56)

Challenge yourself:

Do your children start and finish the day with a healthy meal?

What meals are planned for tomorrow?

Do your children get regular exercise, fresh air and sunshine?

Do they have bedtimes?

Do they receive adequate relaxation and sleep?

Where does the cell phone go at bedtime?

Do your children start the week sluggishly and behind the eight ball because of overdoing it during the weekend?

Are you an organized person?

Children can learn to be organized, but organization is a thoroughly contagious process. In other words, if you want your children to show organized behaviors, then you need to model those behaviors. The only way to do this is by incorporating plans, routines and systems into your ordinary, everyday lives. A good place to begin is to ask yourself if you usually know what is planned for the day. Next, ask yourself whether your children usually know what is planned for the day. Knowing your plan allows your children to synchronize their planned or unplanned activities. No matter what your children's ages are, this basic, respectful two-way communication helps the family run more smoothly. Some families use a whiteboard, blackboard or large notepad to communicate. Placed in a central location, such as the kitchen or dining room, the board or notepad can be used to write messages to better aid

communication and the remembering of tasks. See later chapters for many more ideas on organization.

Planning also allows you to think through what will likely happen during the day and where you can circumvent problems. If, for example, it is too difficult to take a child shopping, then don't take him. Avoid it by finding a babysitter. If you must take your child shopping, and you know it will create some serious challenges, encourage him to have his own shopping list and to look for groceries, and provide a cheap calculator to add up the cost. You could bring along a toy, puzzle or handheld computer game, or let your child play a game on your cell phone. These activities allow him to be engaged. Negotiate before leaving home. If your child follows the rules (e.g., stays in or walks next to the shopping cart, plays his game, etc.), then promise to reward him. Keep the shopping expedition brief, and gradually increase the time.

Challenge yourself:

Are you organized?

Do you usually know where your child or teen is?

List the systems you have in place to support the various aspects of household organization.

Besides yelling, what system supports do you use to get your children to school or to bed on time?

Do you deliberately build structure?

For excitable, impulsive, anxious or easily overwhelmed children, it is the unstructured situations that always prove the most difficult. Children's parties, school dances, large family gatherings, sporting functions and extended play times at a friend's or relative's home can sometimes prove too demanding. In situations where emotional overload is likely to cause an outburst, one idea is to use a rehearsal technique. Plan ahead by rehearsing how the event might unfold. Pinpoint and discuss the times that may prove challenging, and then role-play ways to cope. Rehearsing will help your child to intellectualize the feelings likely to arise, which in turn supports greater composure when the time arrives. Other alternatives are to avoid the situation, limit the time the child spends in this type of environment, or provide support mechanisms to help the child in these situations, such as finding a quiet spot for the child to watch a DVD or play a handheld computer game.

Challenge yourself:

Do you have a list of ideas that you regularly draw on to help your child cope in challenging situations?

Mentally list just four strategies you have used with some success.

Do you behave the way you want your children to behave?

How you behave, treat friends and react to wins or losses profoundly influence how your children will behave in similar situations. Like it or not, our children mimic us. Parents who consciously live happy, well-connected, balanced lives send a potent message about how to live life. Similarly, parents who model calm, thoughtful interactions constantly feed powerful behavioral signals to their children. Their calmness exudes confidence and poise and has a positive influence. Alternatively, modeling the loss of control, disrespect and saying pointless or damaging things in the heat of the moment teaches children to do exactly the same.

Challenge yourself:

What does your child see you do when things go wrong?

How often does your child see you laughing with friends and enjoying life?

When was the last time you did this, and when will be the next time?

Do you offer consistency?

Do you consistently deliver the same messages to your children? Clear, basic expectations and consistent reinforcement (positive and negative) benefit every child and teen. Without established expectations linked to consistently predictable outcomes, children learn to do what they feel like doing, disregard the needs of others and behave 'in the moment' without reflection and consideration. Inadvertently, we teach them to manipulate and overlook the link between their actions and outcomes.

Challenge yourself:

What do you do to show consistency?

Do you have family rules?

Are they displayed and enforced?

Was there a time this week when you helped your child to see the link between his actions and outcomes?

Do you encourage your children to think?

Through discussion, try playing the "What if . . . ?" game. Encourage your child to ask:

"What if I did this? What might happen?"
"What else might happen?"
"What if I chose to do something different? Then what is likely to happen?"
"How would I feel about this choice? Might it work?"

Do you discuss with your children the extent to which they have choices in different situations? Have you ever asked them, "How important is making good choices? . . . Is it possible to choose and make a difference, or is fate, difficulty or bad luck destined to be your master?"

This style of relating and questioning teases out the shades of grey and awakens independent thinking in children. It reinforces the link between feelings, choices and outcomes, helping them understand that making good choices and recognizing opportunity is what life is all about. The earlier children see this, the better equipped they will be to deal with the realities of life.

Challenge yourself:

Have you played the "What if . . .?" game or incorporated it into a discussion this week?

Promise yourself to try it today.

Creating helpful ways for our children to succeed is at the heart of this book. This important endeavor has as much to do with redesigning the thinking of adults as it does with redesigning the thinking of children. Once you gain an understanding of your family's limitations and potentials, realistic opportunities for change emerge.

Finally, never forget that even in the most limiting circumstances, positive changes can be made by tackling one thing at a time and doing it well. You can make the most difference in your child's ability to succeed, because you are the most important influence in your child's life!

Chapter 2

Family Strategies Worth Considering

Establishing rules, creating expectations

A few parents visibly cringe when they hear the words "rules" or "rule-making." Some parents believe that having rules within the family structure will strangle their child's expression or diminish the love the child has for them. Often they simply find that rules are hard work and more easily avoided than set and enforced. The result of this belief is a rapidly emerging group of young people that has been subjected to what's been called "loving neglect." A statement recently released by the British National Association of Head Teachers noted that some parents "love their children too much to say no." The children eat too much, eat what they want, do what they like, go to bed when they feel ready and watch too much television. The problem is apparent throughout all socioeconomic groups and is responsible for creating a group of young people who are unfit to pay attention, unfit to remember things, and unfit to follow instruction, with little respect for their learning.

Let us develop the idea of making rules as a thoroughly positive way for all members of the family to know what is expected of them and, in turn, to know what they can expect from others. Rules apply as much to behavior as they do to responsibility. Reasonable, well developed rules that are actually followed bring structure, predictability and emotional stability to a family. However, basic family rules do require thoughtful, respectful development. They do not just happen. Promoting family rules following an irritating incident isn't the best way to implement rules, as overreaction and strong emotional response often invite nasty impasses.

Begin by asking your children the following questions. Include even very young children, as long as they can understand the basic ideas being presented. (You may have to explain that the word *negotiable* means open to change in certain situations, if the family talks about it and

agrees on the change. For example, a bedtime rule might be bent for a special television program on the weekend.)

"What rules do you think will help our family?"
"What rules should be negotiable?"
"What rules need to be nonnegotiable?"

Just as you know what is likely to help, your children will also. So often, it is not making the rule that tips the balance, but more the act of inviting your children to participate that makes the difference. At the commencement of a new school semester or school year or on a child's birthday are ideal times to review family rules. Naturally, it is easier to negotiate rules if your family has a history of jointly raising and resolving issues through discussion.

Implementing family meetings

Your first response to this idea may be that family meetings seem old-school or corny. This is often the initial response of parents, but so often family meetings reap refreshing benefits simply because they persuade everyone to talk. The essence of a family meeting is to review what is happening in the family—what is working and what is not—and to discuss possible changes and make compromises. Family meetings are excellent vehicles for building relationships and modeling respect and compromise, and they allow healthy change to occur.

Here are a few ideas around which you can design family meetings:

- Set aside twenty minutes weekly, biweekly or monthly.

- Keep this time sacred, avoid rescheduling, and write the meeting on the calendar. It needs to exist in its own right, so do not combine it with meals or television time.

- Keep an agenda sheet on the refrigerator or bulletin board, and remind others to add topics to it, especially when problems crop up. Try not to introduce too much at each meeting.

- During the meeting, turn off cell phones and take the telephone off the hook so the potential for interruptions is limited.

- Parents with younger children often choose to elect a new chairperson and secretary each meeting, which is ideal. Of course, young chairpersons and secretaries will need your support. Parents with teens tend to keep the meetings less formal.

Hint: It is likely that the young members at the meeting will each want a say at the same time, especially when the children become excited about presenting their points of view. To reduce the likelihood of chaos, use a 'talking stick,' which is a stick or wand, which can be decorated if you wish. Only the person holding the talking stick or some other designated item can speak. The talking stick becomes a physical reminder for young children to wait and listen to others until it is passed to them.

- When the chairperson asks, "Does anyone have an issue they would like to raise?" encourage the person with the issue to also suggest a possible solution. Encourage everyone to contribute.

- Make decisions by family consensus rather than majority vote, as majority votes almost always leave some members feeling as though they have lost.

- When a deal is struck, it's a good idea to frame it from your child's point of view. This helps your children see that, through negotiation, things can work in their favor.

Hint: Sometimes it is wise to record the new rules and display them. This provides a concrete model to refer to if clarification is needed. This also reduces the scope of misunderstandings. For younger children, a picture may serve as a written record. For example, to help a young child stop pestering you when you are on the phone, you might draw the two of you in the usual situation, showing speech bubbles. Then ask your child to draw a large red X over the drawing to indicate that this is the behavior to stop. Draw in the agreed upon consequence, should this behavior arise in the future. It may be a drawing of the child missing a favorite television program for that day. Next, draw a picture together showing a new way to deal with the situation. Visual representation supports the child in knowing exactly what to do and what not to do.

- Try to be a wise listener. Aim at finding a common ground. If consensus cannot be reached after a discussion, then put it off until the next day or the next meeting.

- End the meeting with a fun activity. Suggestions include choosing a favorite snack for everyone, delaying dessert until after the meeting, playing a game and so on.

- Be prepared to review and rework rules and expectations periodically.

Outcomes from family meetings do not have to be perfect solutions. Simple ideas that are workable and generally accepted can make a world of difference.

Creating safe retreats

Everyone needs a sanctuary to retreat to at home. It is vital! Most families allocate the bedrooms as safe havens. If someone (child, teen or adult) chooses to go into his or her bedroom to calm down or be alone, that person has the right to do so without another family member demanding attention or calling out from the other side of the door. Giving in to such demands reinforces that bullying behavior and pester power will work. An individual's space and time alone need to be respected, so harassing behaviors should be treated with an immediate consequence from the earliest age.

To remind family members of each person's right to retreat to the bedroom for privacy or solitude, hang a Do Not Disturb sign on the door knob. The sign can be hung when there is something special the person would like to do, such as read, be with a friend, build something or listen to music. It also serves as a reminder to family members not to interfere with the belongings in other family members' rooms. Alternatively, a Stop sign or an Off Limits sign on the bedroom door can act as a reminder. Another option is to install a small hook and eye latch to the inside of your child's bedroom door. More than anything, the lock is symbolic; it reminds family members that they have the right to withdraw in private from the rest of the family when they are feeling overwhelmed. Occasionally, in more serious circumstances where a brother or sister repeatedly shows no regard for a sibling's privacy or belongings, installing a heavier lock to keep the offender out can be effective. This option is best saved for older children, where the older sibling and the parents have keys to the lock.

Saying "No!"

The earlier your child sees you demonstrate that "No" means *No* and not *Well, er, maybe,* the better. With hindsight, we all know it is much easier to deal with a disappointed teenager who has grown up understanding "No" than to face an enraged teenager who will not accept it and will not listen, and who badgers, pesters, insists, threatens, bullies and blackmails to get what he wants. One of the families I work with uses the motto "Three no's, then it is never going to happen" as a reminder to their children to think about what they are saying and doing. It reminds children that if all they do is harass to try to get their way, what they want will never come about. It also persuades children to think about other, more pro-social options to try when occasionally they feel they really must persist.

Managing behavior when things go wrong

Parents regularly say it is sheer frustration that drives them to shout, lecture and complain when conflict suddenly arises. The following two scenarios are likely to awaken a memory or two and put a smile on your face!

Scenario One

It is mid-morning on a Sunday. One of your son's friends has slept over, and his parents are due to pick him up later that afternoon. You are very much aware that both boys are tired and excited. A short time later, you hear giggling, thumping, bumping and laughter from the other end of the house, so you head off to investigate. As you walk into your bedroom, you see 11-year-old Andy, your child's friend, landing after a somersault on your new, expensive bed. You briskly walk right up to Andy and look him straight in the eye. Very firmly, but without much emotion, you say, "Andy, that is not allowed. Hop off, or I'll call your mother to come and pick you up right now." You wait a moment in case Andy needs to respond. Then you walk off, making a similar comment to your son, with a suggestion about finding something more constructive to do.

As one of my clients remarked, "This is exactly what I'd do if one of my child's friends was misbehaving in my home. Why is it so much harder to do with my own children?"

Scenario Two

It is early evening, and the parents are relaxing at home. This time there are no visitors. Everyone has been involved in the usual evening activities. Suddenly, you hear giggling, thumping, bumping and laughter from the other end of the house, so you head off to investigate. As you walk into your bedroom, you see your 11-year-old son somersaulting on your new, expensive bed. Your younger daughter is in stitches laughing and encouraging him to jump higher. You stand at the door and explode! Instantly, you find emotionally charged comments machine-gun firing from your mouth

"Get off that bed now! I can never rely on you to do the right thing."
"This is typical of how thoughtless and disrespectful you are!"
"This proves that I just can't rely on you for anything! You've let me down again."
"You have no respect for the bed, for your father or me or for anything else!"
"You are such a disappointment."
"Have you any idea how long it's taken to save for this new bedroom set? Do you care?"
"Dad and I worked so hard for this and for you kids, and this is how you show your appreciation!"

The truth is that very little of our wisdom or utter frustration is heard by our children. What they hear is mom or dad being in another bad mood, nagging and overreacting again. The rapid rise in our emotional temperature always deflects us from the core problem, because our

uncontrolled emotion lets irrelevant and damaging issues creep in. When we get caught up in this cycle, we fail to help our children recognize what they have done and why they haven't made the best choices.

In times of conflict or when inappropriate behavior has occurred that needs to be addressed, try treating your children more like you would treat the children of your friends!

Shake off your emotion, and follow this code of practice:

- Choose your battles wisely. A wise rule of thumb is to allow 90 percent of your child's behaviors to slip by and comment only on the 10 percent that genuinely matter to you. This helps to ensure the continuation of a healthy relationship.

- When a problem behavior occurs, stop what you are doing and move to your child.

- If you're irritated or angry, allow the initial flush of emotion to pass. As one young teen said to his mother, "Don't call me a psycho if you don't want me to be one!" If your child is showing behaviors that are difficult to control, the last thing that will help the situation is for the parent to demonstrate the same behavior.

- Engage eye contact.

- Use a slow, low, controlled voice.

- Use your child's name, briefly state the difficulty, and remember it is fine to begin by saying, "Susan, I am disappointed . . ."

- For younger children, provide two clear choices that will fix the problem.

- Using as few words as possible, state the negative consequence you will use if the child chooses to continue with the behavior.

- Ask the child to think about it and make the best choice, then walk away. Walking away prevents you from standing over your child demanding instant reform. Any further attention to the problem behavior gives the behavior far more recognition than it deserves.

- Praise your child when he or she responds positively. And don't forget, from time to time when you notice a terrific independent action from your child, give positive reinforcement to highlight this attractive behavior.

- Finally, persist, persist and persist with this code of practice.

Casey broke the rule!

Fifteen-year-old Casey was discovered watching television at a previously agreed upon "no TV" time. Too much television viewing during the school week has been a persistent problem, and his parents had worked with him to create new household guidelines. The negative reinforcer discussed was that Casey would always miss out on an activity over the weekend if he broke the new agreement. His father calmly turned the television off, walked up to Casey, and used a low, slow voice to say, "Casey, we have a deal on this. You've broken it. Your bad choice means you can't go to Tom's this weekend." Then, he walked away and did not engage any further. Casey will soon honor the system, if it is consistently applied.

Cindy wants it now!

Seven-year-old Cindy had a history of shouting and throwing tantrums to get her way. Earlier, Cindy's parents had explained to her that shouting and demanding would always be ignored. They discussed, listed and drew on a large poster acceptable ways she could get their attention. One Saturday afternoon, she loudly demanded that her father drive her immediately to the store to replace her markers so she could continue coloring. Her father engaged eye contact. He used a calm, low, slow voice and said, "Cindy, we have a plan to help you stop bullying to get your way. You need to make a better choice now. If you choose to continue on like this, you will not go to Melissa's birthday party tomorrow. Think about what you need to do." Her father walked away and did not engage any further. Walking away reinforces to Cindy that her father does not participate when her behavior is undesirable. Walking away is also a mild form of punishment, as it deprives Cindy of the attention her demanding ways would often capture. Once again, Cindy will soon learn the system, if it is consistently applied.

"Shhhh, I'm on the phone!"

Without training, children between one and 12 years old nearly always want something as soon as you are talking on the phone. Interestingly, once they reach adolescence, this demand quickly tapers off as they begin to work far more independently, even secretly. Teaching telephone etiquette early will avoid what can become an enduring problem. Develop a warning signal (a reminder) with your child. As your child walks into the room, hold your finger up to indicate that the child should not talk to you, and turn away. Tell your child that you will always attend to his needs as soon as the phone conversation is finished. Also put in place a silent way your children can get your attention if the matter is urgent. Have your child write a message so you can see the difficulty or emergency. If your child persists in demanding attention, break the phone conversation momentarily, move away from the phone to your child, look at him in the eye, and say, "You know the telephone rule. It's the time for you to walk away, or there will be no television this evening. You make the choice." Turn and walk back to the phone. Do not engage with your child any further. All children quickly learn, if the method is consistently applied.

"I'm not going to the zoo. That's a stupid idea!"

Over the years, 10-year-old Tammi had learned to become a superheated powerhouse. By verbally abusing family members when she thought differently or complaining endlessly for days, she knew that her parents would eventually change their minds and she would get her way. It was not unusual for Tammi to hit, slap or kick just to help cement her opinion and exert her full authority. Her mother and father had tried to always include Tammi in decisions, seek her opinion, discuss differences and find compromises. It was a genuinely admirable approach, and it usually worked well for Tammi's older and younger sisters—but for Tammi, the approach had become a contest of words and emotions. In recent times, Tammi's oppositional behavior had become too much, and the zoo incident was the straw that broke the camel's back.

Tammi's parents mentioned they would like to take the girls to the zoo during the upcoming weekend. As had become the pattern, Tammi's opposition and hostility towards the suggestion surged. "I'm not going to the zoo. That's a stupid idea!" she thundered. What Tammi did not realize was that her parents had recently been involved in some training to better manage her controlling behaviors. Her father turned and faced Tammi. He engaged eye contact. He drew himself up to his full height. Calmly and deliberately, using the low, slow voice technique, he said, "That's fine Tammi. If that is your choice, you don't have to come. Think about it, and if you still don't want to come on the weekend, let me know and we will get someone to babysit while we go." Her father walked away. Walking away is a concise way to bring the encounter to a close. It also reinforces to Tammi that her father does not participate when her behavior is emotional and oppositional. Yet again, Tammi will learn the system, if it is consistently applied and enforced.

This basic, respectful, consequential approach is not a cure-all, but it is logical and safe, and it reduces the emotional factor. It maintains the integrity between feelings, choice, behavior and outcome. Without doubt, the earlier the system is embraced, the easier it becomes for everyone. Your consistency, more than anything, will determine whether the system works. The bonus of this style of communication over a period of time is that it tends to generalize into other areas as well. If chronic difficulties persist, it is wise to seek professional help, either through your child's school or with a well regarded counselor or psychologist. The act of drawing on professional support acknowledges the problem and says very clearly that you want to place energy towards improvement.

Organizing your reinforcers

Social reinforcers

For most children, a simple social reinforcer—a smile, a wink, an uplifting comment, a silly face, a tussle of the hair, a nudge or an "I dare you!" with a laugh—provides enough motivation to redirect their behavior. Often it takes no more than developing the art of catching your child doing something worthy, smiling and pointing it out. Experts say that positive reinforcement is most effective when applied immediately following a desired behavior.

Concrete reinforcers

Other children need more tempting reinforcers or rewards, as praise alone is just not enough. They benefit from the use of repeated social and concrete reinforcement to strengthen the rate of required behaviors. Clever parents discuss, develop and display pictures of the reinforcers on the refrigerator or on a bulletin board at the time of designing the expectations. This approach encourages cooperative behaviors and helps to lift adults from what can become a negative cycle while wrestling with their child's difficult behaviors.

Concrete reinforcers do not have to be expensive: extra time on the computer, a new toy, a favorite snack, a trip to the library or video store, collector cards or other collectible items, music CDs, gift vouchers, staying up late, something on the child's wish list or additional minutes for your child's cell phone. For our young children, it's surprising how influential inexpensive plastic toys are!

In some instances, it is best that the reinforcer not be given immediately. Instead, stars, fake money, points or tickets can be offered and later exchanged for the agreed upon reward. This form of encouragement usually leads to increased internal motivation, which, of course, is the ultimate goal.

Negative reinforcers (consequences)

Negative reinforcers concern something your child will seek to avoid in the future: the loss of a privilege, missing out on something anticipated, reduction or withdrawal of pocket money, being grounded, time-out, reflecting on a bad choice, writing an apology or taking on additional chores. Again, behavior experts tell us that when an undesirable behavior is consistently and calmly followed by a negative consequence, the undesirable behavior usually lessens. Unlike positive reinforcers, it is important to use negative reinforcers in moderation. Avoid negative reinforcement unless you are prepared to follow through. If you fail to follow through, your child will learn a very powerful message. He will learn how to not accept no for an answer, to persevere until he gets his way, to ignore you, to ignore basic expectations and to manipulate at a very sophisticated level. The child will learn how to control his parents.

"Hold it! I'll be good from now on."

A frequently asked question is whether children should be allowed to work their way out of a negative consequence. In a nutshell, this is not a good practice. Once children learn they can bargain their way out of a consequence, they are more prone to believe that they do not have to comply in the first place. They know they have a lifeline to trade the consequence later.

What about punishment?

Punishment concerns the use of severe repercussions following unacceptable behavior: strong criticism, shouting, humiliation, slapping, hitting and combinations of these. Punishment holds limitations and dangers. Although it is easy to use, it can encourage the punisher to vent frustration and inflict physical injury, or worse, long-term emotional damage. Persistent punishment may even provoke oppositional behaviors, hatred and mental health issues. With the benefit of hindsight, we now know that punishment tends to reduce bad behavior but lacks the capacity to reshape and create better behaviors. Punishment is more likely to teach young people to hide their mistakes, blame them on others, lie or simply not get caught. Also it is important to see that punishment is not able to fix the developmental delays in children often seen as young and impulsive, who have trouble putting the brakes on.

Challenge Yourself:

If you choose punishment as a control option, challenge your motives for doing so. Ask yourself:

How often do I punish?

Why do I use punishment?

What am I hoping to achieve?

Is the punishment appropriate to the circumstance?

How is the child likely to react, and how has the child reacted to punishment previously?

Is it working for either of you?

What might be the long-term consequences of the punishment?

Designing a written plan to develop new behaviors

Sometimes a written plan that relies on more structure, stronger reinforcers and higher levels of accountability is necessary.

Introduce the plan optimistically. Present it to your child as a way to shake off an old behavior that isn't working and encourage a new one that will help him to reach a new goal. Introduce the idea of concrete rewards as a catalyst, an investment to fire up your child's intrinsic desire to do better!

A plan will not be successful if your child is unable to see its value, so it is crucial to have your child on your side. A good beginning may be as simple as asking your child, "What would take the least amount of effort to make a reasonable change?" This simple question can dissolve antagonism and set the scene for new thoughts, new goals, new habits and some successes. Never underestimate the value of setting goals. Jensen (2000) reminds us precisely and eloquently of their value: "Goals do several things. First, they narrow the attention span to the task at hand. Second, they can provide hope of reaching the goal; the anticipated pleasure. This often triggers the release of the body's feel good chemicals, the endorphins."

List the behaviors to which you automatically react.

Like it or not, when we instantly respond to one of our child's behaviors (positive or negative), we reinforce that behavior. Start by questioning which behaviors are worthy of your response, and consider using the 90 percent/10 percent rule mentioned previously.

Be a detective.

Behavior happens for a reason. The aim here is to find out what the behavior of your child is really saying. Observation is the most beneficial way to do this. To begin with, when does your child start to whine, hit, lose his temper or become moody or noncompliant? Where does this happen? How severe is it? Who is around at the time? Can you see a pattern? Does it happen at the same time each day? Researching the ABCs of behavior is valuable.

A = Antecedents

Can you figure out what seems to trigger the behavior? Can you identify the patterns that seem to precede the behavior, e.g., having to share, interacting with a brother or sister, an annoying brother or sister, sadness, tiredness, homework, anxiousness, immaturity, excitability, inflexibility, poor planning or language difficulties?

B = Behavior

Exactly how does your child act? Write out a description of each behavior you would like to change. What does the child look like? What does he or she say? Then, begin to question exactly how much the behavior really matters. Is the behavior worth tackling? Might changing a routine fix the problem?

C = Consequences

What usually happens following the behavior? What does your child say? What do siblings say or do? What do you say or do? Is what you have been doing working? Why or why not? Brainstorm other options that might be more effective.

Describe the new positive behavior.

First, describe the difficult behavior that needs to be changed, and then redefine the behavior in a positive way. For example, the difficult behavior might be that your child constantly interrupts. The redefined positive behavior might be that the child says "Excuse me" when he wants to say something, then waits to be asked to speak. Help your child understand how he needs to look and sound when using the new behavior. It is crucial to direct your energy towards strengthening the new positive behavior, as research tells us that trying to stomp out a negative behavior is far more difficult. Finally, ask yourself, *Is the expectation I have reasonable for my child?*

Explain the positive and negative reinforcers.

Encourage your child to participate in choosing the reinforcers—positive and negative—as giving the child choices makes the process of change all the more powerful. List the positive reinforcers your child would like to earn, and seize on what truly motivates him. Explain that negative reinforcers will be used only when his old behavior gets in the way of his new thinking. Discuss and agree on when the negative reinforcers will be used. Decide together how you might give a secret signal as a quick reminder to stay with the new positive behavior. Explain to your child that once the unthinking behavior takes over, a predetermined negative reinforcer becomes a nonnegotiable consequence.

Different children like different systems.

Young children, especially those who are busy and impulsive, respond best to immediate feedback and predetermined rewards for using their new thinking. This helps to keep the new goal fresh in their minds. A consistent drip-feed that nurtures compliance and small changes works best as opposed to, "If you are good all week, you can have a reward." Older children are able to respond to more complicated systems that have longer delays built in between behavior and reinforcement.

Write the plan with your child.

Writing the plan with your child helps to cement the child's promise to make new changes. The key to success is making the most of your child's sense of pride. The four behavior change plans provided at the end of this chapter may be reproduced. Photocopy the one that your child finds most appealing, and fill out the new, positive target behavior. Record the goal, stating exactly how often and how much of this behavior is required to achieve the positive reinforcer. Complete the section on the plan for positive and negative reinforcers, and record how each reinforcer will be earned. Formalize the plan by having everyone sign it.

Find a place to keep the plan.

Often families will take photographs of the new, positive target behaviors. Once printed, the photographs can be attached to the plan as a reminder of the new behavior. This will help to strengthen the behavior. The plan and photos can be displayed in a prominent place, where they will act as a persuasive reminder.

Get visual in monitoring your child's progress.

Monitor the changes in behavior by using a visual approach. Traditionally, star charts have been used, but any engaging visual means will do, particularly if it appeals to the child. Creative monitoring systems help children stay excited about their goals, but these systems remain secondary to a thoroughly discussed and sensibly developed plan. Place both the monitoring chart and the plan in a place where they can be seen as often as needed. Ideal places are on the refrigerator, the bedroom door, the bulletin board or a desk. Each day the child is successful, a sticker, a check mark or whatever has been previously determined is added to the chart. The chart in the selected Behavior Change Plan at the end of the chapter may be used to monitor the child's progress.

What about when things go wrong?

When things go wrong, create ways for your child to disagree or show frustration without threatening his chance of success. Discuss this, and role-play how to do it before starting the plan. Work out a safe place that your child can retreat to if feeling overwhelmed or angry. Encourage your child to take the lead.

A reward earned cannot be taken away!

Anything your child has worked for and earned remains his and cannot be taken away. When your child reverts to the old, unwanted behavior and chooses to ignore reminders or secret signals to help him get back on track, a negative reinforcer is given. This helps the child to experience what it is like *not* to meet the agreed upon expectations. It is reality at work, and mistakes are valuable learning experiences. It does not mean you or your child has failed. At

this point, it will take your child longer to achieve the agreed upon positive reinforcement. Your job is to allow for a restart without the undertone of failure or loss of dignity.

Reminders are okay.

If you find it necessary, give frequent or occasional reminders about what is expected and how the child can earn the positive reinforcement. Children identified with Attention Deficit Hyperactivity Disorder (ADHD), for example, are naturally impulsive and are less able to see very far ahead. Our planning has to do this for them. Provide surprise social and concrete reinforcers along the way, too, as this tends to heighten the child's awareness and feeds the drive to do well.

Do what you say.

Follow through on what you say you will do, and once the program is initiated, use it consistently over the agreed upon period. Talk about and review progress. Praise the child's effort and perseverance as well as success.

A common pitfall is to keep on working at the behavior once the initial goal has been achieved. This approach is not about achieving perfection. It is about normalizing behaviors and developing new behavioral successes through improved thinking. When the current plan expires, extend or raise the standard for your child to earn a new reward. This is called building out the program. If you know your child is achieving the targeted behavior for an hour, try it for two hours—and never hesitate to change the physical appearance of the plan to add interest. Aim to remove the tangible rewards when praise begins to make a difference. Otherwise, there is the risk of turning children into reward addicts.

If this chapter has done nothing more than confirm that you already have a poised code of practice, that what you are doing is sensible and that your persistence is important, then it's been a worthwhile read. If it has done more than that, you have had a windfall. Start by playing with a few new ideas, and have fun with them. There is a lot to be gained!

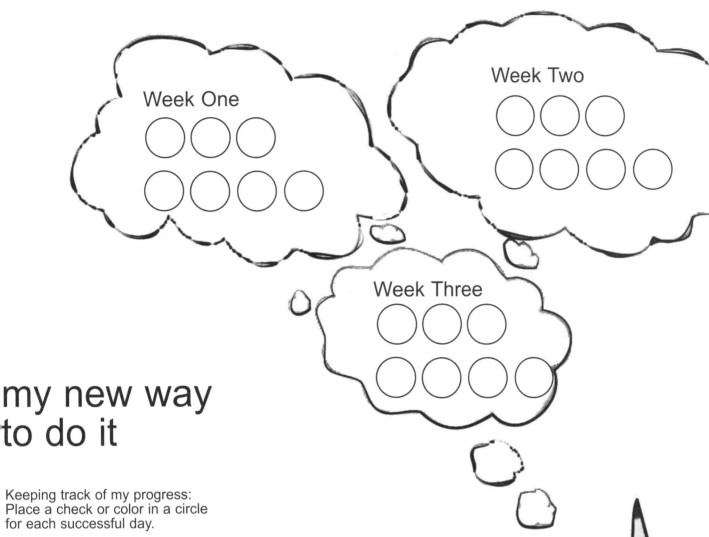

Week One

○ ○ ○
○ ○ ○ ○

Week Two

○ ○ ○
○ ○ ○ ○

Week Three

○ ○ ○
○ ○ ○ ○

my new way to do it

Keeping track of my progress:
Place a check or color in a circle
for each successful day.

Name_____

My new goal is _____

I need to _____

My reward is _____

I can earn my reward by_____

Mom and Dad can help me by

Reminders to help me use my new behavior
are

I agree that when I choose not to do it the
new way, mom and dad will have to

Mom/Dad signature_____

My signature_____

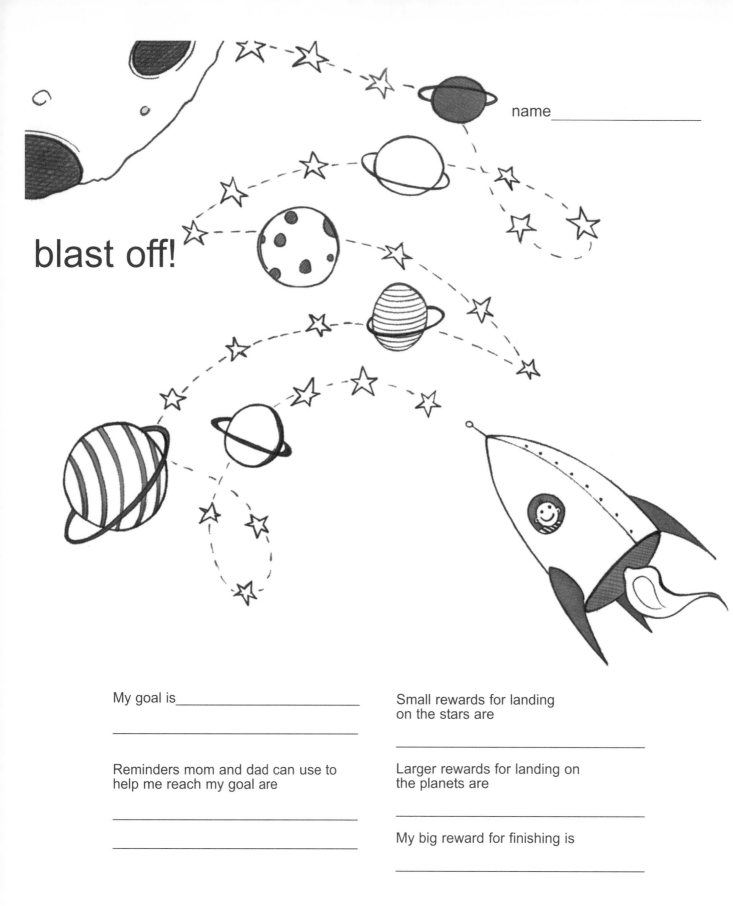

name_____

blast off!

My goal is_____

Reminders mom and dad can use to
help me reach my goal are

Small rewards for landing
on the stars are

Larger rewards for landing on
the planets are

My big reward for finishing is

Each time you reach your morning, afternoon or daily goal, color or place a sticker on the next star
or planet. Finally, when you reach the moon you will receive your biggest reward.

- using sticky notes with reminders
- developing key words
- placing stars on a chart
- playing intermittent beeps on a tape
- making a telephone call
- sending an e-mail
- writing a text message
- doing countdowns
- creating charts
- drawing pictures
- giving a look
- flashing a smile
- making checklists
- writing on calendars
- creating daily or weekly timetables
- repeating the same reminder joke
- wearing the same silly smile
- introducing a sound
- producing an aroma
- playing the same background music to trigger the memory
- giving a touch
- making a gesture
- leaving a message on the dining table
- hiding a note to be discovered in the lunchbox
- taping a sign on a door handle
- taping a message to the cereal box
- placing a note under the windshield wiper of the car
- flashing cue cards

Seize anything that helps to keep the forgetful, distracted or easily overloaded mind to sort priorities and remain with the task. Simple, external reminders, whether they be tactile, fragrant, verbal or visual, support all individuals who do not have well developed internal capacities. If we keep using reminders that gently prod change, a child's delayed internal organizational skills can be progressively expanded.

Build structures and routines.

Providing structure means arranging the conditions at home to provide your child with the best chance to function well. As tedious as it may be, organizationally challenged children rely on explicit training about how to give their attention and how to follow through. They rely on organizational patterns being constantly in place, subtly and overtly: when to start an activity,

how to begin it, how to enjoy it or persevere with it (even if you need to cleverly contribute) and how to finish it and put things away.

Start by designating routines and places where things belong, and play with clever ways to encourage your children to do things the same way, at the same time, on most days:

- Hats belong on the hook or in a box.
- Schoolbags belong in the bedroom.
- Empty lunch boxes belong on the kitchen counter.
- Shoes belong in the closet.
- School books should be placed in the study area, ready for homework.
- Homework should start half an hour (or designated time) before the favorite television program.
- The cat is fed before afternoon television.
- Books go on the bookshelf.
- Supplies are placed on the desk.
- Toys belong in the toy box.
- Dirty clothes are put in the laundry basket when they are removed in the evening.
- Dirty breakfast dishes are put in the sink or the dishwasher.
- Teeth are brushed immediately after the breakfast dishes are cleared.
- The backpack is packed, zipped and ready for school before television is turned on.

Poorly organized children depend on memory prompts to know when tasks need to be tackled, what materials are required and what comes next. They rely on us to create structure and routine to ease their naturally messy or chaotic ways of operating. This applies equally for young teens experiencing the same difficulties, and not surprisingly, the same systems are of benefit, providing they are delivered in a way that maintains the teens' dignity and reflects their maturity.

Help children begin and finish tasks.

A good place to start is to strengthen your child's ability to start and finish tasks. The natural style of impulsive individuals does not include staying on task and seeing tasks through to completion. Their style is to constantly change lanes, and this works against them even though they might want to see things through to the end.

To help children stay with tasks:

- Know what they are tackling.

- Provide the opportunity to talk through how they will tackle the task.

- Check in periodically to find out how they are progressing.

- Ask questions that help them reflect on what they are doing. This is invaluable for those who forget and suddenly find themselves engaged in something else. These sorts of questions can be delivered with little effort: "Jane, why you are wandering around the kitchen?" "Rob, are you finished with what you started?" "Have you made a choice to start something else now?"

- Be prepared to shorten tasks that require persistence. Ensuring the task is manageable also ensures success!

- Encourage your child to take small breaks and return to the task refreshed.

- Rather than letting your child give up because he sees the task as too big, find a point where he can stop or leave it for the day. Give him the chance to buy time and regroup his perseverance.

- Don't be afraid to lend a hand and model how to stay with a task.

- Teach your children the art of self-talk by letting them hear how you talk to yourself as you work your way through a project. As adults, we often use self-talk as we are tackling a project. We know that by talking out the logical order of the project, our motivation and confidence are buoyed. Show your children how they can rely on this as well.

- At a beginning level, introduce ways to help your child persevere with listening to a story. One way to stretch listening skills is to encourage him to keep his fingers busy (by drawing, coloring, holding a soft ball or rolling a piece of clay in his fingers) as he listens. Gradually build out the process by extending the time required to listen. Sometimes, ask your child to retell the story. In this way, you can begin to gauge just how effective his listening and comprehension skills are.

- Guide your children to pack up and put away activities once they are finished. Make it a rule from the earliest of ages that what comes next is dependent on packing up and putting away first.

- Teach your children, no matter what age, to think about what they will need before beginning a task. Ask them to discuss upcoming projects.

Brainstorm ways to be organized at family meetings.

Useful, practical suggestions often come from children themselves. Their ideas regularly show us that we do not have to have all the answers! Use a family meeting to discuss organizational concerns, and ask for suggestions on how to resolve them. Parents who consistently hand problems back to their children to solve provide them with a vote of confidence. Their deliberate retreat from supplying all the answers says they believe their children can think and solve problems on their own. This system helps to create a home atmosphere that promotes self-reliance.

Develop the piggyback habit.

Piggybacking is an appealing strategy to support remembering, and it's so simple! Combine something your child usually forgets with something that is regularly enjoyed or is part of the daily routine. Piggybacking can work for many different things, both at home and at school. Piggyback combinations are endless! Bonnie's daily chore, for example, was to feed the cat after school, but it was something she always forgot to do. Bonnie and her mom taped a small piggyback sign to the television to remind Bonnie to do this chore. When she went to turn on the television after school, she saw the piggyback reminder, and this triggered her memory to feed the cat. After a few weeks, a new routine had started. Piggybacking had worked! Plans are in progress for Bonnie to piggyback selecting her favorite breakfast cereal with remembering to pack her homework, reader and lunch into her bag each morning. One success can lead to another!

Routinely scale down books, folders and possessions.

Clever teachers implement the following plan. Instead of students keeping a hefty batch of notebooks in their lockers, their teachers pare them to a minimum. They color code the covers and arrange for two subjects to be assigned to each notebook—one subject beginning at the front, and the second starting from the back. The combination of having fewer notebooks and knowing that the red one, for example, is for math and science makes keeping track of the notebooks a lot easier.

Another valuable idea is to use a brightly colored plastic folder for assignments in progress. Once the assignment is handed in, graded and returned, it can be filed elsewhere. This allows students to find current assignments in one spot, rather than losing bits and pieces in their bags, somewhere in the bedroom, at school, or even worse, somewhere in between.

What can be learned from these clever teachers? That it is important to keep an eye on the growth of your child's belongings. Without maintaining a check on this accumulation, items begin to clutter the schoolbag, bedroom and house, causing chaos and adding to organizational

difficulties. If you know your child is unable to organize, then it is up to you to tactfully control the growth of the mess!

Keep schoolbags tidy.

It is challenging for poorly organized students to keep all things in order. This is just the way it is. Keeping schoolbags well organized usually proves to be especially difficult. The ideal approach is to not allow schoolbag tidiness to become an issue of importance. Instead, make an arrangement to go through the schoolbag with your child once a week. Establish the system so it's up to your child to take the leading role. No doubt you will be amazed by what is discovered scrunched in the bottom of the bag! The two of you might find notes, newsletters, library books, lunch bags, toys and food. At issue here is the development of a functional habit and the feeling the child will have of beginning the new week knowing exactly what's in the bag. Finally, if you think this approach is suitable only for young children, you couldn't be more mistaken. This approach can be used effectively with motivated but disorganized students in secondary school. If promoted tactfully and consistently, it works beautifully.

Organize the school pencil case.

Make sure your child owns and uses a pencil case. It's invaluable for containing small items, such as:

- pencils
- colored pencils
- pencil sharpener
- crayons
- pens
- eraser
- glue
- ruler
- small scissors
- protractor
- compass
- highlighters
- markers
- notepads

Keep the approach simple. Each evening, reorganize and restock the pencil case with the basic requirements. For a poorly organized child, organizing both schoolbag and pencil case must be adult-driven, but it can be orchestrated so your child contributes to the process.

Make rules for borrowing, and allow for losing things.

In Kenneth Shore's very practical book, *Special Kids Problem Solver,* he offers a shrewd idea about borrowing. Shore suggests the rule that when a child has to borrow from another, he must offer something of his own as security. Once the loaned item is returned, so is the security deposit. Also, at the time of negotiating the loan, it is best to agree that if the item is not returned at an agreed upon time, the borrower must pay some kind of penalty. This is very sensible and so real life!

As with borrowing, it's necessary to keep losing belongings in perspective and help out where possible. All of us lose belongings, and generally, children lose and misplace belongings more often than most adults. I recall a 10-year-old boy telling me that his mother had bought him a box of pencils with his name on them that he secretly kept in his school locker. This short-circuited his problem of not being able to find his pencil some days. He smiled as he explained that usually some of his pencils would show up before the box became empty. What an ingenious mother!

Add structure with cell phones and organizers.

More and more young people carry cell phones. A local school recently determined that, by fifth grade, at least 85 percent of the students regularly carried cell phones at school. This technology is here to stay. Teach your child to take advantage of the organizing systems built into cell phones. Some cell phones include calculators, reminder notes that appear with attention-getting sounds, built-in alarm clocks, stopwatches, cameras and count-down timers. It is a bonus for children to know how to use these systems, because their cell phones rarely leave their sides.

Handheld organizers are fabulous for everyone, with or without organizational issues. An expansive range is now available. At the top end are the pocket PCs and Personal Desktop Assistants, referred to as PDAs, and these offer amazing functions *(www.hp.com)*. Yet, those at the less expensive end are easy to use and worthwhile. They can be programmed to beep as reminders flash on the screen, displaying what needs to be done. Homework, notes, reminders, tasks, phone numbers and so forth can be typed in. Visit your local electronic retailer to investigate. You won't be disappointed.

Provide supportive structures through the computer.

For some young people, mastering basic keyboarding and word-processing skills can provide the edge to maintain order and find success. Presentation looks so much better, and the computer can help to check spelling and grammar and save work, storing it in neatly arranged folders. This is so much better than physically handling papers and risking their loss. Most children are ready to start keyboarding by early primary school years. If you do not have the

skills or the time, arrange for an older teenager to teach your child essential computer competencies. The following checklist is suitable for most middle to upper primary school-aged students:

Computer competency checklist

- Type.
- Create and begin writing a document.
- Undo mistakes.
- Change font, font size and color of print.
- Use spelling and grammar checks.
- Access the thesaurus.
- Check the word count.
- Cut and paste.
- Use auto-summarize.
- Access drawing documents.
- Save and retrieve the same document.
- Save as a different file.
- Save onto a floppy disk or USB flash drive.
- Retrieve from a floppy disk or USB flash drive.
- Burn a CD.
- Create and label folders for storing files.
- Access and send e-mails.

Encourage your child to learn to type.

Keep in mind that an extensive range of CD-ROMs offer typing tutorials for all ages. Most are inexpensive and can be purchased from local software stores. Elementary-aged children are almost never too young to begin to explore the keyboard and learn to type, but there does come a time when they become too old, too busy and too resistant to learn. Seize the moment now!

Create reminders.

If you own a Macintosh computer, teach your children how to construct "stickies." These are easily made messages that appear on the screen as the computer boots up. Stickies can be used to remind, explain how to complete a task, give homework instructions, or provide phone numbers or websites that need to be remembered. Similarly, Microsoft Office Outlook can be used as a wonderful memory jogger, having the capacity to set up lists and timelines for assignments and reminders.

Have your child listen to text.

New technologies have revolutionized how information can be gathered from print. A student can actually listen to text on the screen being read out loud, so instead of constantly tripping over a reading problem, the child can access higher level thinking skills. Nuance Corporation *(www.nuance.com/realspeak)* has developed amazing software to convert text into surprisingly high-quality speech, in both male and female voices. Alternatively, go to *www.fullmeasure.co.uk* to download a free program called Cliptalk. It allows whatever is copied onto the clipboard to be read back. Also, when using the Web, you'll be astounded at the hundreds of free e-texts that are able to convert text into speech! Simply type *free e-texts* or *e-texts* into your search engine. With the computer reading out loud to the student, electronic literacy has the capacity to turn a nonreader into an eager learner. (Try *www.promo.net/pg* for Project Gutenberg, which electronically provides many famous and important texts for free.)

Access free interactive learning.

New technologies also offer amazing options to strengthen spelling, writing and numeric abilities for children of all ages. Many helpful Internet sites contain fun interactive activities and programs that teach skills and improve confidence. The following sites and their links are great starters:

Chateau Meddybemps for parent information and interactive games
www.meddybemps.com

BBC School for phonics and letter-blend activities
www.bbc.co.uk/schools/wordsandpictures/index.shtml

Funbrain for reading and math games
www.funbrain.com/kidscenter.html

Curriculum resources for reading and math worksheets
www.manatee.k12.fl.us/sites/elementary/palmasola/pstrread.htm

Starfall for letter sounds and reading activities
www.starfall.com

Use software help for writing and editing.

A word processing program called textHELP Read and Write Gold *(www.texthelp.com)* is intended to be used alongside Microsoft Word. This program can read words as they are typed, read back text, check spelling and automatically correct frequently made errors. Its capacity to read back the text on the screen enables the user to listen to what he or she has written, making

it invaluable for editing and proofreading work. Similar word processing and prediction programs are: Text Ease 2000, Text Help, Clicker 4, Penfriend, ClickNType, Co:Writer 4000 and Kurzwell. (See *www.dyslexic.com* for more information on most of these.)

Talk to the computer to make it write!

It's true! New generation software now converts what is being said into print that appears on the screen. The future is here, and what's more, the price of this product continues to fall. Dragon NaturallySpeaking for Windows *(www.voiceperfect.com)* is useful for students who have handwriting problems or spelling difficulties, or who can't type or just don't like typing. It allows the student to say what he is thinking and get immediate results in print! Training with the program doesn't take long, although younger students (middle primary) require a training plan. Usually, students will see an improvement in the speed and accuracy of voice recognition within a few days and find it inspiring!

Organize ideas.

It is worth exploring the computer programs Inspiration and Kidspiration *(www.inspiration.com)*. These two programs allow both young and older children to flexibly organize their ideas on the screen. They can help students to brainstorm ideas for assignments or keep track of what is happening in each chapter of a novel. Later, the information can become the basis of a Word document or a PowerPoint presentation. Try Smart Ideas Concept Mapping *(www.smarttech.com)* for more ideas related to organization and thought development.

Incorporating prompts into routines

Simple prompts help children who don't have well-developed internal capacities to stay on task and be organized. Without these prompts, cues or reminders, it's too easy for these children to lose their way. Prompts can appeal to the tactile, olfactory, auditory and visual senses.

Tactile cuing

Tactile cuing requires minimal effort and prompts children of all ages to stop and think and override their automatic responses. A tactile cue can be as simple as a touch on the arm, a tussle of the hair, a rub on the back or a gentle punch on the arm. Any of these signals can become a reminder to redirect a child's attention, to sustain his perseverance or increase his tolerance. Following is an example of how one parent used tactile cueing with her daughter.

Thirteen-year-old Beth constantly exhibited poor eye contact, especially outside of her home. She knew this and understood that eye contact is an accepted social behavior that brings benefits. However, she felt uncomfortable looking straight into people's eyes. Instead, Beth and her mom decided it was better to look at the forehead of others. She needed reminding to build this new approach into a habit. The cue, when in company, was for Beth's mom to stand near her and lightly brush her hand. This simple tactile cue, used

over months, reminded Beth about the new behavior she wanted. By strengthening and reworking it, this new behavior became incorporated into her day-to-day dealings with others. This process is called training to proficiency, and it can be used to reshape all manner of behaviors.

Develop the signals together with your child. Your hand on his shoulder at a family gathering may signal that your child is doing really well, or it might mean that he needs to think about how loud or emotional he is becoming. Similarly, some parents place a small toy or coin in a child's hand, which delivers the message, *"It's time to take a walk. Go to the car and grab your computer game to play, and give yourself some space to cool down."*

Olfactory reminders

Olfactory reminders, or fragrances, are not used as commonly as tactile, visual and auditory cuing. Perhaps it's because they are less convenient and require a little more planning. However, there are many parents who vow they are helpful, so they are worth a mention. Rosemary and lime oils are frequently recommended to enhance concentration, while cedarwood and frankincense are used as relaxing agents. Some parents feel that burning an oil burner or using an oil diffuser when quieter times are needed, such as for homework, helps their children to start and persevere. Others affirm it also works in the evening as a cue for their children to start winding down and begin pre-bedtime tasks. The improvement is likely to be linked to a phenomenon called time-place cuing. That is, by doing the same thing at the same time each day, a series of powerful time-place cues are sent to the brain.

Visual cueing

Every person has a unique style that works best when receiving information. Have you noticed whether your child performs best when he can see what he needs to do (visual cueing)? Or, does he respond better to spoken instruction (auditory cueing)? The task as parents is to discover which style of prompt works best to optimize your child's performance. To be safe, it is best to use a combination of auditory and visual cueing. Following are some ideas to enhance visual reminders.

Display a daily timetable or planner.

Poorly organized children rely on the parent's tenacity to preserve simple organizational patterns. A household schedule supports children and teens alike in knowing when to: unpack the schoolbag, hand over school notices, put the lunch box on the kitchen counter, start homework, make their lunch, be ready for breakfast, put the dirty clothes in the laundry basket, brush their teeth and so on. Children rely on being taught the order of routine, and a timetable is a striking visual tool that can help create organizational success without the need for parents to shout directions.

Consider purchasing a whiteboard, blackboard or bulletin board, and permanently create a two- or four-week planner. Alternatively, purchase the largest wall calendar you can find and hang it in a central location. Start to use it, and encourage everyone else in the family to use it. Assist the children to record due dates of their assignments, school field trips, family reminders and family outings that are in the near future. As plans change, discuss the changes and make alterations. As this becomes routine, the children will begin to see the value of this simple but effective organizational device. A reproducible weekly planner is provided at the end of this chapter. Use this reproducible form or create your own.

Teach your child how to look.

Does your child really know how to look? Does he know what he needs to look for in order to have the best chance to receive and remember visual information?

Children with distractible traits do not have a natural temperament to do this. They require ongoing training to look at the eyes and faces of people when they are being spoken to, or they will always fall short of seeing what is happening and knowing what is expected from them. Children need to know a set of behaviors that will help them to look, remember and follow directions. Encourage your child to think about this, and be mindful of modeling appropriate 'looking behavior' to strengthen the emerging skills. This is also a good time to start to extend eye-contact messages. Work on it together, and rehearse the meanings behind a wink or different types of looks. I recently overheard a delightful man I work with snap at his seven-year-old son, and I was really impressed with what he said: "Tom, my eyes have flashed at you twice in the last five minutes over this. You will need to look and take notice of what they're saying. This time I'll tell you, if they flash again and you don't see it, then that's it!"

Grab the attention!

When it's time to give an important instruction, hold up a strange or bright object as you speak. Or, slip on something visually striking, such as a hat, a coat, a jacket, plastic glasses, a plastic nose, a scarf or a glove. Use the same prop every time. Despite how you may look to others, this is a powerful cue to remind a child that now is the moment to look, listen and remember. Parents who use this to perfection do not overplay it and never repeat the instruction once it is given. Otherwise, there is no incentive for the child to listen when it really matters. Explain this to your child. Start using the technique early, because it is something you will be able to use for many years to come.

Keep reminders in sight.

Forget what grandmother said! Writing a reminder on the hand does not mean you are uncouth. Allow your child to jot a reminder on his hand using a pen, a stamp, or a marker. If there is more than one thing to remember, use a pen to write a key word on each finger. In addition, colored wristbands, a rubber band around the wrist, even colored tape around pens

are useful reminders that will jog the memory. It's more than just a novel idea. Reminders used in this way work, because they are within the child's visual attention span at all times.

Have highlighters on hand.

A highlighter makes a world of difference to help remember, understand and organize. Teach young children to scan text and highlight key words and phrases. Good places to begin include highlighting the information in school newsletters, proofreading work and prioritizing research information. Using a highlighter also provides the opportunity for children to slow down and sort through information while using their busy fingers and minds. Eventually, your child's middle and secondary school teachers will be appreciative of this early, consistent input, as secondary teachers often lament over their students' inability to accurately highlight relevant text.

Use charts to show progress.

Often large tasks and assignments have too many steps for children and young adults to complete successfully. An option is to create a simple chart that represents the individual sections that need to be completed on large assignments. Or, create a chart of the individual subtasks, and assign dates for completion. Encourage your child to color, stamp, place a sticker on, or check off each of the subtasks when completed.

Teach how to use lists.

As adults, most of us panic when we are suddenly caught without our lists. Whether it is a shopping list, a work task list or a home task list, it reminds us what needs to be done and encourages us to set priorities. Yet, we often forget to openly teach and reinforce this ordinary, effective remembering strategy. The best idea is to keep the list in the same place and make sure it can be seen daily. Arrange for your child to keep his list on the bulletin board, attached to the bedroom door or desk, or on the refrigerator, bathroom mirror or table. Your child will see it, add to it and live with it as a part of the daily routine. Don't forget to attach a pencil to the list!

Buy or make checklists.

Checklists are also valuable, because they have the flexibility to contain word or picture prompts. Checklists don't take long to make on the computer, or they can be bought from office supply stores. Just as for regular lists, a checklist can be attached where it is most likely to capture your child's attention and trigger his memory. A checklist similar to the one displayed at the end of the chapter is useful, as it breaks down tasks into smaller steps. For example, a checklist might include the steps involved to:

- get ready for school
- put the correct belongings in the backpack
- prepare the desk for homework and begin
- prepare a simple meal

- put away the tools in the shed after use
- do a task, any task
- keep the study area organized
- pick up the bedroom
- get ready for bed
- use assignment books for homework tasks

Make a poster to help stop clutter.

Many children and teens need to know how to stop the growth of clutter on their desks. Make a poster to show precisely where items should go on the desk. (This may require a little clever negotiating.) Post it on the wall above the desk as a reminder, or fasten it to the desk, and use markers to create outlines showing where the pencil case, ruler, pencils, pens, books and so on should be placed. Give plenty of encouragement, but also accept the fact that the physical organization of belongings is tricky for the poorly organized, and these children will need to rely on adult organizational systems for some time.

Alex asked his father to help.

Alex, a bright 17-year-old student, wanted to be better organized, and he appreciated the value of an orderly filing system. He always felt he worked better when his desk was neat, but maintaining this order independently seemed hopeless. I recall Alex affectionately describing his father as a "neat freak," and perhaps he was. Alex recognized his father's organizational strength, so with a little persuasion, he asked his father if he would help him to organize the filing systems in his bedroom and take joint responsibility to keep things more orderly. This meant giving his father permission to discreetly tidy his desk on a regular, on-going basis. This union still continues some 12 months later, and Alex's mother can see the world of difference it has made to Alex's assignment completion and test results as well as his moods and his relationship with his father.

Auditory prompts

Auditory prompts include anything from a friendly whisper of encouragement to openly calling out, "Oh! You need to put that down. It bites!" The style most commonly used with children is barking out instructions, requests, directions, orders, reminders and reprimands. While calling out the instructions might seem efficient to the adult, it is obvious that most children become overly accustomed to their parents' voices. It doesn't take long before the child tunes out and becomes 'parent-deaf.' Surprise your child by whispering or miming an instruction, or saying one puzzling word that makes him turn to you and wait for more to be said. Try anything that will change the usual into something new and unexpected!

Teach listening behaviors.

Some children just don't know how to listen, as listening is not a part of their natural set of communication tools. They may be inattentive or may tend to live in their own worlds.

Children with these styles often say that they *did* listen, and they really believe they did, but they didn't, because they have never experienced true listening.

True listening is a highly developed habit that needs progressive guidance over a long period of time. For children who have not been explicitly taught to listen, it is unrealistic to expect them to suddenly start to listen without training. Children need to know the set of behaviors that will help them to listen, remember and be more successful. Begin by discussing what they need to look like when listening. Teach them what the head, eyes and body need to be doing in order to give themselves the best chance to remember spoken information. Have them watch others on television, and point out those who demonstrate good listening techniques and those who don't seem to have a clue. Even the youngest children are up to understanding and practicing this. Better listening means they are ready to absorb information, create ways to remember it, follow directions and act independently.

Engage younger children in listening.

Here are several ways to improve the readiness of young children to listen:
- As you point with your finger, say, "Look at my left shoulder. Now my right. Now my lips. And now, listen!" Or try, "Watch the cards I'm holding. They're counting down from five. When zero comes, you will need to remember what I will say next."

-

- Simply playing a burst of Simple Simon Says can raise listening readiness.

- Insist that your child look at you while you speak. Let your child know that you will not speak until eye contact has been engaged.

Develop a key word or phrase as a cue.

A number of families I know use a key word or phrase as a reminder for their children. When the child says, "Huh?" or "What?" the key phrase response might be, "Think about it." This encourages the child to replay the information or instruction given and reach a little more deeply into his auditory memory. Likewise, when a situation begins to become emotional and tension starts to rise, these parents use a prearranged key word to indicate time-out is needed. Then, the parent moves away, as walking away takes pressure off the child to immediately reform. This provides everyone time to regain composure, rather than reacting and saying dreadful things in the heat of the moment.

Use fewer words.

Make your instructions shorter. Make each word count. Provide fewer choices.

Say it and let children see it.

Whenever possible, use visual clues to complement verbal instructions. For example: point to the illustration in the book as the explanation is provided; write brief details of the task on a piece of paper for your child to take; draw an illustration to emphasize what needs to happen; or in addition to saying it, jot the message on the whiteboard at home. Listening memory difficulty is truly an irritating problem, as it can so easily undermine a child's self-confidence and make him feel as though he must be dependent on others by always seeking reassurance.

Pair instructions.

Develop a habit whereby you always state instructions in pairs. Make a point of this, and soon your child will automatically expect to remember two items each time you ask for something. For example, "Grab the book in my bedroom and put it on the dining room table," or "Go outside and bring in the newspaper and the dog food." As your child matures and understands the system, try extending it. Take it to the next level and group instructions into threes: "I want you to remember three things. One, clear up your desk! Two, put your belongings in your schoolbag! Three, return to me with your lunch box!"

Counter "Whatdidja say, Mom?"

To stop your child's confusion when listening to instructions, ask, "What is it you need to do?" immediately following the instruction. State the instruction, and have your child repeat it.

Have your child do tasks and errands with a friend!

Asking your child to complete a relatively simple task in the company of a sibling or friend can be an effective way to elevate the listening memory, as most children usually perform better in public. This approach also legitimizes the opportunity for a forgetful and easily disorganized child to consult with a friend upon performing the task and watch how the friend does it.

Give information before it's needed.

Pre-teaching, or providing new information before it is required, will always improve your child's capacity to understand and perform when needed. By providing new information and allowing the child to process this information overnight, the child will likely deal with the upcoming events more easily.

Helping your child manage time and task

Many children and young adolescents, beyond those diagnosed with memory and concentration issues, consistently display procrastination, poor planning and difficulties with time management. They find large schoolwork assignments that require independent research challenging. They are uncertain about how and where to begin and what to use; they are unsure where to find the

information and become confused about prioritizing what is important; and consequently, they feel overwhelmed by the whole process. In the end, it becomes so daunting they'd rather let it slip by than tackle it. This is often called time blindness.

There are strategies to support all students with time blindness. The following approach is a practical process.

- First, discuss the time management issues with the child's teacher, so you know where you can provide support.

- Set up a simple checklist with your child to remind him of what needs to be done. The checklist might include: recording where each piece of information can be found; reading the information (which you might choose to read, while your child highlights key phrases and sentences); writing reminders on the contents page (which always helps with planning); collecting diagrams (printed from the Internet); deciding where hand-drawn diagrams will go and labeling diagrams; inserting main headings and subheadings; writing or typing relevant information under headings and subheadings; compiling a bibliography; checking spelling; doing a word count and so on. Teach your child to check off each item as it's done.

- Provide your child with a jump-start by helping your child organize the timeline. This also can be done by an older child, a teacher, a tutor or a friend. Spend two or three different sessions one-on-one early on to monitor the progress.

- Once your child reaches middle primary school, it is time to teach him how to use AutoSummarize effectively (www.microsoft.com). This technology is found in the latest versions of Microsoft Word. AutoSummarize can identify the key points in electronically downloaded articles and reports. Although the program does not do well with fiction and its summaries are not perfect, it is easy to use and brings into focus only the key points from each piece of reading.

- Maintain the routine. Incorporate the activity into whatever happens, virtually every day, until the task is done. Also remember that adult supervision is required.

- Frequently check the work by creating catch-up times. During catch-up times, figure out solutions to circumvent the difficulties you instinctively know will arise. At each of these times, break down the remaining tasks into smaller, more easily managed pieces. Chunk precisely what needs to be done in the time remaining until the next review meeting, and ensure your child knows what to do.

- Together, keep an eye on the time. Encourage your child to record his work on a chart, as this will guarantee he will complete the segments the same as his peer group.

- Alternatively, there is a chunking form provided at the end of the chapter to record what needs to be done and when it is to be done. Create time in the day when the task can be attended to, and remember, adult supervision is required.

- Home help is vital, although be careful to keep your child engaged rather than taking over and doing it for him. Cultivate this by speaking with your child's teacher about the best way for you to support his developing independence. What really counts is that your child feels as though the time management process has worked for him, and that he has been a major player in steering the process and the achievement.

- Be patient. It takes longer for the children who are the focus of this book to gain independent research-based skills. Work together, giving them the opportunity to watch, listen and discuss various ways to read, research, chunk and present information. Gradually, by providing appropriate structures, students develop independence. They learn to conquer time management and to plan and ask for help, and they know how to stay in control.

Get your child involved with time and timers.

Teach children how long one minute, five minutes, or half an hour really is. Time-blind kids need this practice, and lots of it! A practical way to do this is to make them timekeepers for games (even if a timekeeper isn't really required). Find a three-minute timer, a 10-minute timer or a stopwatch, and allow your children to use these as they tackle homework or a household chore, take a shower, run an errand, pick up the doggy-doo, or wait to use the computer or television. Timers are strong visual reminders about the progression of time and can be an incentive to stay with a task for just a little longer. Knowing that the timer only runs for ten minutes can help a child persist, rather than feeling as though the work and time will never end.

Contract time management.

As we drive along a country road, we are usually conscious of the white posts passing by. Finally, as we are almost at our destination, the last white post blurs past. This strong visual parallel can be applied to ensure that school essays, assignments and commitments are completed on time. Think of it like this. The end of the highway is the due date for the assignment, and it would be perfect for our children to progress through their assignments, little by little, as each of the white posts flash past. In this way, the volume of work would be progressively weighted against the available time remaining. One of the reproducible pages at the end of the chapter can be used for chunking tasks in this way. The alternative, of course, is watching the child panic the night before the assignment is due, as the last white post flashes by.

Rather than relying on the last white post to set off your child's panic or motivation, aim at encouraging him to visualize several white posts along the journey. Try this suggestion. Ask your child to tell you when he is given his next assignment. Record the due date in his assignment book and in your calendar. Also record when the reading and notes must be completed and a deadline for the rough draft. This begins to increase the chance of arriving at the destination with the assignment comfortably complete. This is external reminding, pure and simple. It assists in managing time more effectively for people who don't have well developed internal reminder systems. It isn't about parents making a son or daughter accountable to them. In fact, all your child is relying on is the reminder from you.

Above all else, once you have negotiated and agreed on sensible structures to help your child manage the planning and organization, if your child subsequently chooses not to engage in the plans of support, refuse to become caught up in the last-minute emotionalism. Refuse to participate writing an assignment with him the night before it's due. If you regularly find yourself doing this, think about the message you are delivering. It says something like this: *"Why should you take seriously any of the planning ideas we have put in place to support your success? After all, despite my bitter complaining, I always bail you out at the last moment, don't I?"*

Keep an afternoon journal.
Work with your child to find out how he spends his time after school. Does your child really know? Do you know? Can he account for those four or five hours each day, which add up to around 20 hours per school week? Surprising as it sounds, he may not be able to, as he may have developed habits that simply fritter away time. Ask him or help him to keep a time journal. Have him keep it for two weeks. The result is often very revealing, as it exposes what your child is doing. This information can set the scene to create blocks of times in the day when he can have fun and unwind, but also time when he can attend to what he needs to do.

Should there be planned consequences for disorganization?

The answer to this involves walking a very fine line. As I wrote in my last book, "On one hand we have an appreciation that many students find organization genuinely difficult, and we accept that it may even be part of impairment. Yet, if we continually allow students to forget and ignore sensible organizational structures and routines they have helped to put in place, they have no incentive to improve and to get it right."

Allow the natural consequence for forgetfulness and poor organization to take care of itself. In other words, avoid rescuing. If your child often forgets his basketball shoes despite setting up a system to help him remember, then allow him to be inconvenienced by not being able to play. If your child forgets his homework, despite setting up a system to help with homework

organization, allow him to be embarrassed or annoyed rather than running around after him and dropping the homework off at school. Reflect on your own life. What was it that helped increase your desire to become more independent? Most likely it was your annoyance over being personally inconvenienced that increased your desire to become better organized.

A practical close

This brings the chapter to a close, but as we appraise it, we must realize that parents have an obvious choice to make.

As a parent, you could refuse to accept the basis of your child's organizational and planning difficulties. You could make a decision not to do anything about it and continue to respond with criticism and scolding, if that has been your pattern. However, if you settle on this approach, it is certain that your child's poor habits will persist and that he or she will continue to feel unsuccessful. Worst of all, resentment is likely to worsen in your relationship with matters that could be progressively improved.

Ideally, you will accept the root cause of the organizational and planning difficulties that plague the children who are the focus of this book. That is, they lack the individual building blocks responsible for higher-order organizational skills for the moment. Once this salient fact is truly understood, it is far easier to see just how imperative it is to make adjustments by developing sensible structures and maintaining realistic routines. This approach will not only compensate for your child's innate inconsistencies but will introduce practical ways to change old, ingrained habits. There is no other way, and what gives the greatest hope is that the triggers and prompts available to remind, jog memory and support organization are infinite!

Thirteen-year-old Zach and his parents provide a snapshot of how to put some of these ideas to work.

Zach had long been troubled by procrastination and organizational difficulties. He also battled a handwriting disorder, which limited the production of written work. After reading this chapter, his parents provided a range of ideas to Zach. Together, they developed a plan using the ideas everyone felt they could live with. They typed up the plan, put it in a prominent position as a reminder and then spoke to others who were involved in the plan.

Zach's Organizational Plan

At school

- To keep the school locker tidy, Zach will clean his locker and dump everything into his schoolbag every third Friday and bring the contents home. Mom and Zach will sort

through it, and Zach will return the items he wants to keep in his locker to school the following Monday.

- Zach will take his assignment book to each class to record the homework assignments and due dates for new assignments.

- At the end of the school day, Zach will check his assignment book while at his locker, so the correct books are packed to take home.

- Zach will keep two pencil cases—one in the schoolbag and one in the locker. The pencil cases will be regularly checked and restocked. This will be Dad's responsibility twice a term.

- Zach will use a red plastic folder for all work-in-progress papers.

- Zach will have a weekly meeting with his homeroom teacher to discuss the work-in-progress assignments and whether he will need additional help.

- Zach will wear his USB memory stick around his neck to transfer work from his school computer to his home computer.

At home

- Mom and Zach will sort through the schoolbag and pack it up for each new week on Sunday evenings.

- Dad (with Zach's blessing) will reorganize Zach's bedroom. It will be de-cluttered and redesigned.

- Mom and Zach will reorganize the desk in his bedroom so it is clear and is a comfortable place to work. It will be Mom's responsibility to keep it clear.

- Mom and Zach will use sticky notes more often as reminders.

- A whiteboard will be added to Zach's bedroom wall and used as a four-week planner. The weekly timetable will show the best times to tackle homework. Dad and Zach will maintain this.

- Zach will have his schoolbag packed and ready for the next day before going to bed.

Skills required

- Zach will continue to improve his typing speed and develop touch typing skills.

- Zach will continue to use Dragon NaturallySpeaking to keep homework manageable.

- Zach will learn to use checklists as reminders. A pencil and checklist will be kept in Zach's place at the dinner table.

Time management

- Zach will begin to wear his watch every day.

- Zach will begin to use an alarm clock to wake up 15 minutes earlier each morning.

- Zach will begin homework one hour before dinner and try to have it completed by dinner time.

- To improve Zach's idea of how long some of his homework tasks will take, he will start to set a timer to compare his progress.

- Watching television, playing computer games and making phone calls will occur later in the evening, after his homework and other commitments are complete.

Consequences

- Mom and Dad promise to no longer help Zach with "forgotten" assignments the night before they are due.

- Zach will miss activities or lose privileges for obvious avoidance, disorganization or forgetfulness.

Zach's experience provides an example of how thinking things through, creating a plan, and developing routines can help to bring more order and harmony to a child's life. You can use Zach's plan to help your own child, and chances are, you will notice how it benefits the whole family.

name_____

my weekly planner

A planner helps you to remember what to do AND when to do it! Fill in the planner
so you will when to: tidy your schoolbag, do homework, do your chores,
watch TV, go to bed, go to karate, clean your teeth, finish a school assignment, etc.

time	Mon	Tue	Wed	Thur	Fri	Sat/Sun
8:00 – 9:00						
9:00 – 10:00						
10:00 – 11:00						
11:00 – 12:00						
12:00 – 1:00						
1:00 – 2:00						
2:00 – 3:00						
3:00 – 4:00						
4:00 – 5:00						
5:00 – 6:00						
6:00 – 7:00						
7:00 – 8:00						
8:00 - 9:00						

my four week planner

name_____

Fill in the planner with up and coming events such as assignment due dates, family outing, vacations, and special events.

Week	Mon	Tue	Wed	Thurs	Fri	Sat/Sun
one						
two						
three						
four						

my checklist

name_____

Checklists are great reminder tools. They can also be used to break a task down into smaller steps. Place the checklist where you will see it and can update it easily.

name_____

topic_____

the task

start this part on

the task

start this part on

the task

start this part on

the task

start this part on

the task

start this part on

chunking tasks

Here is one way to keep an eye on time! When you begin a task, record the smaller steps and the time the task should be started.

Chapter 4

Plans to Overcome Typical Home Hotspots

Creating optimistic relationships

If you see your child's performance as awkward or impossible, your child also is very likely to be aware of the problem. Your child will know that his fleeting concentration, bossiness, under- or overreactions bring negative comments and responses. Your child also will be able to identify the issues that regularly bring about the clashes at home. Some of these issues may be:

- getting out of bed on school mornings
- getting ready for school on time
- remembering homework
- completing homework
- returning homework to school
- keeping the bedroom clean
- remembering daily chores
- spending too much time with the television, telephone or computer
- going to bed on time
- staying in bed at night
- losing the school lunch box and school notices
- being selfish

A healthy, loving relationship encourages warm human interactions, and these can bubble to the surface as a smile, a wink, a silly face, a nudge, a dare, a joke, saying "I love you," a thumbs-up or a kind and reassuring comment. The benefits of positive human interactions are remarkable and provide the scope to make mistakes without causing a catastrophe. Using the words "I'm sorry" more freely offer us a little more leverage to influence our children to change

behaviors that are not working for them. Without quality relationships, these ideas hold little more than a collection of patch-ups that might result in some temporary control.

Changing your child's angry reactions

It is expected that children and young adolescents will reach angry flash points occasionally. Periodic outbursts of shouting, swearing, teasing and even being fairly physical are considered well within normal limits. When somebody explodes, it may not necessarily be a sign of disobedience or defiance. This eruption may indicate intense emotional overload that cannot be easily processed or intellectualized into an appropriate course of behavior at that moment. Sometimes, displaying anger has gotten an individual what he has wanted in the past, so he develops a pattern of becoming angry to get his way. He can become accomplished at harassing, exploding, threatening and intimidating to have what he wants. These behaviors receive zero tolerance in schools and workplaces, and having regular temper tantrums or using physical or verbal abuse are unacceptable ways for any family member to try to get what he or she wants at home.

With reinforcers, Kyle learned to control his anger.

At home, eight-year-old Kyle was in control of his family. He'd learned that shouting, screaming, swearing, hitting or damaging things paid off. Inadvertently, he had stumbled across a powerful, but socially inappropriate, weapon. It seemed that the smallest frustration set this friendly, likable boy off on a rampage. His mom, Karen, knew he became quickly annoyed by his two younger sisters, and they knew and used this as well. Kyle always regretted being angry after the event. Kyle and Karen decided to try a new system to help tame his anger. From then on, when he felt angry and knew he might hit his sisters or his mother, he was to place an angry-face sticker on a bull's-eye chart. Kyle smiled, saying, "That way the angry feeling can stay on the bull's-eye and not in me!" Kyle could do this independently and tell his mother he had done it, or if Karen saw a situation escalating, she might put a sticker in his hand as a prompt.

To begin with, gaining five stickers would achieve a small reward. Kyle adored zombies, ghouls and aliens, available in inexpensive colored plastic at most toy shops. Once he received this initial reward, his next goal was six stickers, and a new reward was negotiated. After the program had run for four weeks, Karen introduced the idea of negative reinforcement, or consequences, because now Kyle knew there was a way to step aside from the angry choices. If he chose to become angry and hurt, it would attract the consequence of missing his beloved television episode for that day. Karen delivered only two consequences to Kyle. She also kept a small set of positive reinforcement pictures on the bulletin board and made sure to offer one of these as a bonus for great effort. As well as supporting changes in Kyle, this approach also supported Karen to move from her previously despondent attitude towards Kyle to a more optimistic outlook. In the space of three months, the frequency and intensity of Kyle's automatic angry outbursts had diminished. He was much easier to be with at home, and he had relinquished some of his intense desire to be 'in charge' of the family.

When dealing with anger issues, deal with them openly. During calm times, discuss the problems and try to normalize them in the best way you can. Recognize anger as a genuine and powerful emotion that needs to be dealt with in respectful ways. Holding anger back or suppressing this dynamic wave of energy often results in an uncontrolled explosion somewhere else. Develop exit procedures, or ways for the child to escape the situation with dignity before the emotion spills over. Teach the child to automatically remove himself as he approaches the point of no return. Teach him to retreat in such a way that his dignity remains intact. Show him how this can be done at home, at tennis, swimming, soccer or when visiting friends—and when the child attempts to do it, reward him for doing so! In the meantime, teach your child that you will remove *your*self if he cannot remove *him*self from the situation in the home. It is not foolproof, but it's a start.

In calmer times, discuss with your child why he chose to use anger to show disapproval, annoyance or disappointment. Ask whether it is a behavior he believes gets him what he wants. Ask how long into the future he believes this will continue to work for him. Does it make him feel powerful or feel embarrassed? Gradually disarm anger as the preferred way to function. My experience in working with children experiencing difficulties with anger control is that most of them feel terrible after the event. Generally, the child becomes his own worst critic. Children frequently say it helps when their parents calmly walk away from their angry outbursts and don't buy into it by demanding an instant apology.

The key to dealing with anger is finding acceptable ways for your child to let this raw emotion loose without placing the angry individual, or others, at risk. There are many ways to transfer this emotional surge to the physical. Depending on the age and temperament of the child, some of the following suggestions may help:

- punching a pillow
- ripping up a foam "destructor pillow"
- hitting a punching bag or mattress
- taking a deep breath and walking away
- finding a quiet spot and doing some deep, slow breathing and relaxation exercises
- taking a shower
- jumping on the trampoline
- going to a friend's house
- drawing a picture of the person you are angry with and tearing it into pieces
- shredding a newspaper or magazine
- ripping a kitchen sponge into a 'thousand' pieces
- breaking play dough or clay up into very, very tiny pieces
- throwing a ball repeatedly at a target
- writing an angry letter and tearing it up or putting it into a safe, private place

- adding a new entry to the anger journal
- listening to music with a headset
- going somewhere private and screaming
- using a friend as a sounding board
- jogging or taking a long walk
- talking to someone the child trusts
- writing a story about the annoying person and creating a different outcome

The best results occur when the child or teenager latches on to a particular strategy and repeatedly uses the same strategy over and over. Developing a new habit reinforces a new pattern of behavior, and quite soon the new habit becomes automatic.

Self-monitoring

The act of simply monitoring one's own responses can have a positive effect on many behaviors. This approach has long been used with success to help people lose weight and quit smoking. The process of thinking about and recording a targeted behavior becomes a bridge to make stronger connections between feelings, behavior and what they want to happen.

Target one behavior you would like to see less of: shouting, whining, crying, demanding, being angry, saying no, having to be first, hurting others and so on. Or, target a behavior you would like to see a lot more of, such as: answering the telephone, making connections with friends, helping out around the house, saying yes, remembering a chore, smiling and so on. Ask your child or teen to record the behavior you have jointly agreed to track every time it occurs. It's a good idea to track a behavior every day at the same time, when the likelihood of the behavior is most common. Set it up in a positive way that invites the participation of your child. Present it so the child's integrity remains intact while positively reviewing the progress. It is amazing how this simple act can result in such improvements. Eventually, you may wish to extend the process and aim at achieving specific targets negotiated together, and you might consider attaching incentives. 'Sweeteners' can really assist!

Improving your child's contributions around the house

What about assigning chores?

The idea behind assigning chores is to spread out the tiresome domestic load. It's all about operating as a team around the home—and in theory, it seems like a perfect idea! In fact, it really can work well, if you follow the guidelines discussed below. Setting up and enforcing chore routines may be more work for you initially, but you will end up having to do less, and your child will develop a sense of responsibility and self-worth.

Many parents expect their children to participate, and sometimes they unwisely decide to attach pocket money to chores. Some parents believe this will encourage the children to be more diligent, and for some children, this system does work. However, when offering pocket money doesn't really improve children's dedication to chores, parents and children often become locked in a damaging power struggle, week after week after week. If pocket money is to be part of the chore package, it is best to make the approach success based. That is, anticipate what your child can and will achieve each week, rather than offering a substantial payment and consistently withdrawing it because of failure. If you feel as though you are caught up in a cycle of nagging and failure, postpone pocket money for chores until your child has matured and you have sharpened your success-based 'chore tools.'

The golden rule is to match the chore to your child's interests, skills and abilities. For young children, start chores at the simplest of levels. Select tasks that the child prefers, as he or she will have more potential to succeed. In the early stages, it is important to modify the chore if your child is overwhelmed. Also, be prepared to be flexible with respect to how well the chore needs to be done. Consistency and willingness should rate far more highly than a perfect completion. The aim is for your child to make fairly successful contributions to the household without too much fuss.

A final thought is prompted by the attitude my mother and father had about chores as my brother and I grew up. As children and teenagers, we were expected to do a few basic things: make our beds, put our dirty clothes in the laundry basket, tidy our bedrooms occasionally, clean out the dog's kennel and take out the garbage when asked. We were never asked to regularly sweep, mop or polish floors, dust, vacuum, do laundry, iron clothes, wash or dry dishes, wash cars, clean windows and so on. Yet, we regularly received pocket money. I recall my father saying, "You don't need to worry about too much for now. You've got a lifetime of chores ahead of you." Such words of wisdom! The considerable lack of practice I may have suffered throughout my childhood doesn't seem to have disadvantaged me as an adult.

Trent has a point system for chores.
Trent and his mother, Diane, devised a point system that inspired the 11 year old to contribute more around the house. Left to his own devices, Trent would do nothing. With the point system, he could earn a point each day for feeding the dog, two points for loading the dishwasher, one point for making his bed and two points for taking out the recyclables. If Trent completed his chores during the week, he was able to achieve 30 points. Dianne and Trent decided on a formula to convert points to dollars, and once every three to four weeks, they would buy something that Trent could not usually have. His first two purchases were two, new, hardcover Star Wars books. Diane was very clever. Prior to implementing the system, she deliberately stimulated her son's Star Wars appetite. A brief visit to the bookstore allowed Trent a chance to hold the books, flip through the pages and decide on which books he would like to have. This simple step set the scene for a successful outcome. In the ensuing weeks, Dianne was happy to prompt Trent, but the

beauty of their simple system was the way it dramatically reduced his resistance and forgetfulness. It required little effort to maintain and monitor, as largely Trent could be counted on to record the points on a sheet taped to the fridge. It was a truly win/win solution.

"Clean up your bedroom—now!"

Children's bedrooms are usually a problem for parents, because most children and teens can live with the mess and most adults cannot. It's one of those universal laws!

Before leaping into action, think the problem through. Does a neat and tidy bedroom really matter? What priority should a tidy bedroom take in the whole scheme of things, when you know your child is battling with other issues in life?

Challenge yourself:

Are your expectations reasonable?

Are you asking for more than your child can deliver?

Does this really need to be a priority?

Why is this so important to you?
Should it be?

What would be lost or gained if you eased back your expectations?

Do you have a clear idea of what would be acceptable?

Parental expectations that are consistently higher than a child can achieve simply create continual antagonism. Ironically, bedroom tidiness is often the trigger for broader-based friction. Decide how tidy the bedroom really needs to be. When you ask your child to clean it, think about whether the task is too big for him. If the mess is big enough for you to roll your eyes and think, *"What a mess! Where would I start?",* then it's too big for your child to tackle alone, whether the child is six or 16 years of age. In addition, it becomes even more daunting if your child battles with spatial and organizational difficulties, distractibility and lack of persistence.

If you know your child cannot keep his toys and belongings in order, perhaps you need to reduce the number of items in the bedroom. Either weed out items through negotiation, or do it gradually over a period of weeks, quietly removing and safely boxing the items and putting them into storage. After several months, bring a few items back into the house and box up

another set of items that aren't being used. The overriding principle is to stop the growth of mess by pairing down the number of items in the bedroom. Go for a designer's streamlined minimalist look!

To avoid conflict or setting children up to fail, a standard approach is to chunk the instruction. Try saying:

"Hey, just clean up your desktop today."

"Please put your shoes back into your closet before you watch your TV program."

"Put the books onto the bookshelf. I'll help you start."

"Clean up the floor space in your bedroom."

"I want you to reorganize your top drawer. Call me if you need some help."

Chunking tasks helps to avoid overload, which so often leads to procrastination or refusal or an ineffective attempt to clean up the room. So start small! Draw a map of the bedroom, and define three or four distinct areas within the room. Work with your child to choose two areas that will be his responsibility to keep clean and one or two areas that will become your responsibility. Look closely at the balance between the support, structure, and incentives and negative consequences you may be offering.

One fun idea is the 'bedroom slave strategy.' Once or twice a week, offer a three-, four- or five-minute period where your child can take either parent into his bedroom, and for each item the child picks up and puts away, the 'bedroom slave' has to pick up, put away or rearrange something requested! It's fun, and it consolidates the art of putting items away. Some children need this sort of prompting for a long period of time, as a change in habit does not become automatic in a month or two.

For children who habitually fail to clean up the mess and refuse to engage in negotiation, you may need to go one step further. One approach is for you to clean the bedroom, or a part of it, with your child. Select a time that is mildly inconvenient for him. You will, of course, ensure that it takes much longer, is tackled far, far more thoroughly than the child would do himself and is quite tedious. Very quickly, he will learn it is better to clean up adequately his own way rather than do it his parent's way.

Alternatively, the plastic garbage bag technique is an arrangement that keeps toys and belongings confined to where they should be. Let your child know that spreading toys on the bedroom floor or throughout the house is to stop. Designate exactly where the toys and other belongings should be put. Once your child is finished playing, remind him that he has five

minutes to return the toys to their place. If the toys have not been cleaned up in five minutes or have been dumped elsewhere, then quietly, without complaint, place the toys safely in a plastic bag or box and take them to the garage. When your child wants his belongings later, he will need to retrieve them. This seems to be a calming process for parents, as they have permission to clear the clutter immediately. It's also groundbreaking to discover that many toys, once out of sight, are totally forgotten. Occasionally review and fine-tune the rules. It may be helpful to resurrect a few of the toys from the garage periodically as a means of developing a new system or restarting the existing system.

Finally, watch how you speak to your child. "Go and clean up your bedroom—right now!" is not the approach to get a successful result. Instead, employ the skills you use in situations outside the home to get what you want.

Avoid the dumped schoolbag.

Where do you want your child to keep his schoolbag? Are you tired of tripping over it as you walk in the door or along the hallway? Here's an easy solution. Try it for one school term or until the old habit changes to a new one.

Obtain a large, heavy-duty sheet of white plastic, about one square yard in size. Place the plastic in the predetermined location for the schoolbag. Do this with your child, and encourage him or her to place the schoolbag, lunch box, drink container, homework books, etc. separately on the plastic sheeting. Using a large permanent marker, trace the outlines of the belongings onto the plastic sheet. Remove the belongings, and write the name of each one inside its tracing.

Explain that, effective today, this is the only safe place for these items. For children who are compliant but disorganized and forgetful, the benefit is immediate. The white plastic sheet is like a beacon! For children who are less interested, consider adding a consequence when the bag is dumped somewhere else. Explain that whenever the bag is not on the white plastic sheet, you have the right to hide it anywhere in the house for as long as you want. If you need to resort to this, keep the game amusing and flippantly annoying. Ultimately, your child will see that it is easier to place the bag in the agreed upon place.

The role of TV and games

Television and electronic games in children's bedrooms

Locating a television and an array of electronic games in a child's bedroom is a fatal mistake, with the exception of the following two situations:

- The child is highly motivated and extraordinarily self-disciplined.

- The television in the bedroom eases devastating tension thrust onto family members every night by a sibling. In such a circumstance, the television may help to shield family members from extreme behaviors.

The previous two situations are far from the case for most families. Yet, it is startling how many children's bedrooms are gradually being transformed into mini electronic amusement parks. Many a child's bedroom is now packed with such equipment as a computer loaded with the latest action games, Internet and telephone connections; a PlayStation or PSP, Xbox, TV, cell phone, video recorder, iPod, CD or DVD player and handheld electronic games, to mention a few!

If you have given in to your child's insistence to have a television and perhaps an assortment of other electronic equipment in the bedroom, it is time to spend a moment and examine why this has evolved and whether or not it's advantageous. Only on rare occasions is there a powerful reason for parents to locate a television in a child's bedroom.

Challenge yourself:

Is this the way it is in your home?

If so, why have you contributed to this?

Have you been pressured?

Has it just evolved?

Is it advantageous to your child at the moment?

How is it an advantage or disadvantage?

Are you happy to live with this?

Do you need to restructure and make changes?

Clearly, from the child's point of view, if there is a choice between being stretched out on the bed watching television or completing homework, reading, attending to chores or interacting with the family, television almost always wins. This is especially the case for students with learning, motivational, persistence and organizational difficulties.

If the television is already in the bedroom, why not consider relocating it to a shared space? Once the television has been removed, rearrange the bedroom with your child so it's no longer a movie theatre or game room and perhaps becomes more conducive to tackling a little homework or sleeping. This conveys a clear message about your values. Few children are able to independently regulate the amount of time they spend on the Internet or playing electronic games and watching TV. They rely on parents to monitor and limit these activities. The establishment of daily TV/computer free time (about an hour) within the family routine is a popular idea. Sensibly setting and maintaining limits for our children is one of the greatest gifts we can provide.

Watching movies at home with the family

A common problem for families is coping with a child's restlessness or overactivity while watching a movie together. One family I know utilizes two techniques that seem to help. Before starting a movie, the length is determined and the family decides on how many interruptions will be acceptable. The number of interruptions varies according to the child's age and abilities. If four interruptions over a 90-minute period are acceptable, four circles are drawn on a sheet of paper. Each time the child gets up to go to the bathroom, get a drink, find food, check on the family pet, check the computer or do anything at all, a circle is crossed off and the movie is paused for two minutes. When all the circles have been crossed out, the agreement is that the movie will continue to play without further interruption. There is no longer an option for the child to insist it be stopped. This visual approach helps the child pace himself throughout the movie. Another alternative is to place four objects, such as board game pieces or small toys, in the child's hand, and each time he gets up, he must forfeit one of the objects.

Ideas to reshape early-morning organization

For most of us, the morning rush is wearing. There is so much to do—getting the children out of bed and ready for school, preparing or overseeing breakfast, reminding the children to brush their hair and teeth, preparing lunches, getting to the bus stop on time—and all of this is just for the children. You still have to get yourself ready! For some families, this time is well-organized, and for others it is complete chaos. Wherever your family falls on the 'getting-ready-for-school-and-work continuum,' you can take certain steps to make life easier.

Sometimes this doesn't take much time or planning at all. The key to conquering morning chaos is to involve everyone in a bit of advanced planning to create the routine. Once a morning routine is created, the routine can be as comforting as it is convenient. What's more, you and your children are far more likely to get out the door on time and feel as though you're in control of your lives!

1. Start your morning routine the night before.

The best kept secret to smoothing out the morning routine is to prepare as much as you can the night before. As part of the evening routine, it is helpful to chat about how the day went and what the next day has in store. By doing so, upcoming events are given the opportunity to jump into the forefront of your child's mind. Some families take this planning a step further. On Sunday evenings, they look ahead together at the week and map out the upcoming activities on a calendar or family planner.

2. Deliberately build an extra 15 minutes into each morning.

Admittedly, it's a little harder to get up a few minutes earlier, especially in winter, but the extra few minutes can provide a buffer and ease a lot of stress. If you can't leap into this for five mornings a week, just pick two mornings to start.

3. Use morning checklists—one for each child.

Analyze a typical morning in your household. Make a list of what needs to be done by each person. This also is a good time to take stock of the things that need to *stop* happening. Discuss the critical things you need each of your children to do each morning. Photocopy *My Morning Checklist* at the end of this chapter, or make one of your own. Display each child's checklist in a place where he or she can easily see it as the morning progresses. Even very young children are capable of following a list of simple prompts. No doubt each of your children will respond with different levels of interest and enthusiasm. If you have a child who is easily distracted and not terribly interested in following the routine, don't despair! Make him a mini-sized checklist, laminate it, put it on a chain and let him wear it as a morning reminder. Your part is simply to add a few gentle reminders, such as, "How are you doing on your checklist this morning? Show me what you've done."

4. Get kids out of bed with a dose of humor.

A class of primary students suggested the following ways for parents to get their children out of bed on school mornings. Try these for a touch of inspiration!

- "Send the cat or dog to annoy them."
- "Roll them off the bed and leave them wrapped up in their quilt on the floor."
- "Grab the blankets and run."
- "Turn on the smoke alarm."

- "Hold their nose so they jump up trying to get air."
- "Take one thing they really need from their room for every two minutes until they get up."
- "Make a surprise loud noise."
- "Change the clocks and tell them they're running late!"
- "Instead of having one alarm in the bedroom, have three that go off five minutes apart."
- "Say, 'I give up! You can stay home.' Then you'll have to deal with the principal!"
- "Turn the fan on in their face."
- "Turn on the lights and make the room really bright."
- "Put on irritating 1970s music until they get up."
- "Spray an air freshener they hate in their room every five minutes until they get up."
- "Blow a whistle and keep blowing it."
- "Take their cell phone and don't give it back until they are ready for school on time."
- "Zap them on their feet with an electric zapper."
- "Sit on them and play 'poke them all over.'"
- "Lead them out with hot chocolate or something yummy to eat."
- "Tape an ice cube to their leg or put ice down their back."
- "Just stand in the room really still and stare at them."
- "Stay and talk about boring stuff until they can't stand it anymore and have to get up."
- "Smile at them, request nicely they get up and offer a treat."
- "Make funny noises every time you walk past their bedroom."
- "Tell them sheep are jumping backwards over a fence. Start counting down . 99, 98 . . "
- "Later that day play a practical joke on them. Do it each time they won't get up."
- "Go nuts! Yell at them to get in the shower. Be bossy!"
- "Start to cook bacon and eggs or something that smells really good."
- "My mom made a star chart for me. When I got five stars in a week, I got a present that I wanted. I thought it was stupid, but it worked."

My appreciation goes to Heather Davis, the teacher of these creative students.

5. Avoid making breakfast a big issue.

While eating breakfast and having a drink is important, if your child balks at breakfast, avoid turning your worry into a daily battle. Negotiate something your child will eat and drink, even if it is in small quantities, and pack extra food in the lunch box for him to nibble on later. Take him shopping to choose a breakfast that's acceptable. If your child selects the breakfast food, it may help strengthen the promise to eat in the morning. Pancakes, toast, croissants, some juices and some cereals are not ideal breakfast foods, but something is always better than nothing. Nutritious sources of breakfast protein include milk, cheese, yogurt, beans, peanut butter, soy products, white meat and eggs. Other good choices include whole grains and fruits. The experts

tell us that by mixing these foods, the body has fuel longer, because blood-sugar levels remain higher over a longer period.

If you can manage the time, sit down with your children and have ten minutes of face-to-face conversation. This is the time to notice their good behavior. Let them know how much you appreciate how quickly they finished their morning routine and how well their jobs were done. The quality of the morning routine can set the tone for the whole day, so a little thoughtful input from parents at this point can produce a great result!

6. Start off on the right foot.

How we wake up and face the morning sets the tone for the rest of the day. Your child may be slow to wake up and may often be surly in the morning, but you need to take a look at your own mood as well. If your mood is not the best, ask yourself what you can do to change it. Appreciate mornings as a critical time, and plan accordingly. Read the situation and sidestep, ignore or surprise to transform the expected ugliness into something unexpected. Be thoroughly inventive.

How Laurent's mother reshaped his morning routine

When Laurent woke up, he was alert, invigorated and ready to play! That didn't necessarily mean he would get out of bed and promptly do his before-school tasks. In fact, quite the opposite occurred. Laurent had developed the habit over the past 10 years of annoying, needling and niggling at his mother each morning. She felt tired, sluggish and reluctant to face the day, yet the morning routine demanded a degree of motivation and organization. "Come on, Laurent. Hurry up! Breakfast is on the table!" These triggers of urgency would prompt Laurent to start making his noises—little screeches, squeals and clicking sounds with his tongue. They were incessant and drove his mother to distraction. He dawdled over tasks, whining and complaining and baiting his mother, inviting her reaction. I asked Laurent why he did this and whether he knew it really upset his mother. His response was straightforward: "Yeah, she's so grumpy in the morning. I just like winding her up."

To remedy Laurent's problem behavior, his mother made a few adjustments to her morning routine. She set her alarm earlier and started visiting the gym two mornings a week and walking with a friend two additional mornings. This put her in a better frame of mind when facing Laurent. She felt a step ahead of him, as she was already on the move.

Laurent's breakfasts and school lunches were prepared the night before. Organizing his toast and cereal gave Laurent something to do once he dressed. His father deliberately remained engrossed in the morning paper, although he had never been a target for Laurent's pranks. Once his father had finished his breakfast, he expected Laurent to have finished as well. If not, Laurent's breakfast was put in the refrigerator, and they went to the bathroom together to brush their teeth.

As Laurent's mother arrived back home, her husband left for work. Instead of fussing about Laurent, attempting to guide him through the rest of his morning routine, Laurent's mother needed to shower, dress and prepare herself for work. She orchestrated the morning routine so she was no longer in Laurent's firing line.

7. Streamline time spent in the bathroom.

Try the option of using the evening for baths and showers, and then all the bathroom is needed for each morning is a face wash and a few minutes to brush teeth. There is also the matter of hair styling. Some children, especially as they get older, spend a lot of time on their hair, and this can eat up valuable morning time. My time-tested advice is to go with it! Visit the hairdresser. Purchase the right products, and keep the hair cut to the right length so the style can be efficiently reproduced. You might consider having fun with a stopwatch as an incentive to help family members keep moving along in the bathroom. Discuss a reasonable amount of time for morning bathroom tasks, and have your child set the stopwatch when beginning.

8. Establish a destination—a time and place to meet before leaving the house.

Obtain a drop box for each family member to keep by the door that everyone uses to leave the house each morning. This is the place that everyone needs to gather at the designated time to leave. The drop boxes are used to hold keys, musical instruments, schoolbags and anything else that must accompany each person to school. One family I work with uses four plastic crates, each in a family member's favorite color.

How Alex was persuaded to go to school

Ten-year-old Alex didn't particularly like school, but neither did he hate it. He was bright enough, did reasonably well academically and had good friends. What he didn't like was the work and being told what to do by the teachers. He explained that his teachers insisted he complete tasks and do things the way they wanted him to do them, and he found that "boring."

Gradually Alex began to refuse to go to school. At first he feigned sickness, and his approach was convincing. He explained that it was important not to overdo the groaning, but as soon as he awoke and knew his mother was within earshot, he'd start making little groaning noises. As expected, Sal would ask what was wrong, and he would tell her that his tummy aches were back again. He knew his mother would then touch his forehead to check his temperature. Alex's technique was to cup both hands over his mouth and feverishly exhale warm air into them so it was pushed over his face. When his mother felt his face, it seemed warmer and moister than usual, and this convinced her he was probably running a temperature. On one occasion, his mother responded, "Alex, I don't think you're running a temperature. You are fine to go to school." Instantly, Alex replied, "Mom, feel my hands. They're all sweaty!" This became a new fallback tactic. He had licked his hands to make them moist!

Within a few weeks, Alex reached a point where he simply refused to go to school. His father was always at work at this time of the morning, and Sal couldn't budge him alone. In an attempt to stay at home, Alex would lock himself into his bedroom, hide in closets, climb the backyard tree and not come down until midmorning or stomp around the house screaming, crying and running away from home when anyone approached him. Increasingly his father was being called home from work to convince Alex to go to school, but essentially it was a losing battle—and Alex knew it!

Naturally, Alex's school counselor investigated what might be happening at school that could be worrying him: bullying, friendship difficulties, the state of his relationship with his teacher and so on. Her discussions with Alex revealed that the driving force keeping him at home was achieving one-on-one time with his mother, his idol. Despite the shouting, screaming, crying, running away and even seeing his mother distraught, he felt his persistence was worth it. It got him what he wanted, because when his mother returned home from dropping his three younger brothers off at school, he had her all to himself. Alex would say he was sorry, and mean it. Sal would hug him and make his favorite breakfast. After a late breakfast, Alex watched television, played computer games and played with his dogs. But best of all, he was home alone with his mother. He didn't have to share her for the day with anyone else in his family.

Alex's assistant principal was a truly resourceful woman. She wrote a letter to Alex on official school stationery, requesting an interview to discuss his attendance difficulties. The letter asked Alex to bring along his mom and dad, and the assistant principal explained that she would need to invite the principal as well. At the meeting, the principal explained to Alex that his attendance at school was compulsory and that she and the school staff would now do whatever it took to get him to school each day, because this was the school's responsibility.

Alex's clever assistant principal set up an attractive incentive program to encourage his attendance at school, and Sal guaranteed Alex some one-on-one time with her each week as he maintained his school attendance. Most importantly, the assistant principal promised that no matter what it took, whether it was help from his father, a relative, a neighbor, the police or a teacher, Alex would attend school every day. This was the new expectation, and it was accompanied by predictable outcomes.

9. Should there be consequences for continuing morning lateness?

Most of us see punctuality as a symbol of readiness and respect to others. As parents, we need to model punctuality in order to encourage it within our children. If your child, no matter what age, continually decides not to get out of bed on time and not to participate in the morning routine, then allow him to experience the consequence of being late. Resist covering up for him by writing excuses to the school, and refrain from nagging, threatening or pleading. Permit teachers to make negative comments, and let your child's actions attract direct consequences. After all, consequences are attached to every choice that is made.

Plans to Overcome Typical Home Hotspots

If you are really struggling with your child's unwillingness to be punctual, it's wise to speak to teachers about the problem. Teachers are well aware that students who experience impulsivity, distractibility and planning difficulties often experience trouble with the morning routine. Most teachers are able to make excellent contributions to help the mornings at home flow more smoothly. If, despite everyone's best efforts, your child persists in arriving late, the teacher may apply the three- (or four- or five-) for-one rule. That is, for every minute the student is late, the teacher exercises the choice of inconveniencing the student for three, four or five minutes during any part of the day. It may be at recess, at lunch, during a favorite lesson or after dismissal. Students bright enough to consistently think through disruptive and delaying tactics in the morning are also bright enough to realize that getting to school on time is their best option.

Another option when you are truly struggling with morning punctuality is to involve the child's principal. Ask that the principal write a formal letter on school stationery to your child explaining the legal requirements of attending school and being there on time. The letter needs to clearly point out the action the school system is compelled to take if the student makes a choice not to cooperate. A further option, depending of course on the age and nature of your child, is to simply walk out of the house at the prearranged time and let him find his own way of getting to school. Or, arrange for the police, principal or designated school personnel to knock on the front door to pick up your child a few minutes after you have left. Your child will need to directly work through the appropriate consequence with the school.

In a few instances, children need to go through the uncomfortable process of getting dressed in the car on the way to school. This should be executed precisely and unemotionally, with adult backup, as a predetermined consequence for persistently poor cooperation. It may need to be repeated several times to reinforce that you will follow through on what you say.

How Anthony's morning routine was revitalized

In desperation to improve Anthony's morning routine, his mother, Helen, bought him an alarm clock. Wisely, friends had reassured her that this was important in encouraging Anthony to become more independent. At 11 years old, Anthony's morning routine followed this pattern. Helen would wake him, allowing plenty of time. Anthony would complain, roll over and drift back to sleep. His mother would return 10 minutes later, kiss him, tousle his hair, whisper loving morning messages and start to pull the covers back. Anthony would grab the covers and tell her to go away. Helen would explode. This galvanized Anthony into sitting up and gazing at his clothes for quite a while. Slowly, he gathered his clothes, moved to the television and sluggishly buttoned and zipped. Helen would hound him to speed up, get to the breakfast table, eat his breakfast, take his dishes to the sink, pack his bag, brush his teeth and feed the dog. Of course it was Helen who ended up feeding the dog, packing Anthony's bag, and taking the dishes to the sink, while Anthony gazed at the television or wandered. Anthony usually drifted to the car with toast in

his hand and Helen carrying his schoolbag for him. Anthony seemed immovable, and invariably Helen was late for work. This became increasingly stressful, and Helen knew she couldn't sustain the morning chaos much longer. She told Anthony that changes had to be made, as without these changes she was either going to lose her job or go mad. Helen explained the new rules:

Anthony was to set his alarm each night. Helen would check it to be sure it was set when she came in to kiss him goodnight.

No television or computer games were allowed in the morning until all of Anthony's morning routine was completed.

To save time in the morning, Helen decided that Anthony should shower in the evening.

They agreed on 10 morning tasks and made a morning checklist to reinforce these. Now Anthony could check them off as they were done. This checklist was displayed on Anthony's bulletin board in his bedroom.

Providing Anthony completed his 10 morning tasks no later than 7:45 a.m., he could watch television until it was time to leave for school. Television viewing had now become linked to his efficiency.

Helen also presented incentives to accompany the plan. Anthony would earn two marbles in a jar when he completed his morning routine efficiently. He would receive one marble for the first five steps on his morning checklist and a second for the last five. When Anthony accumulated 20 marbles, Helen promised to buy him his long overdue sleeping bag. Anthony's passion was camping, including all the equipment it required, such as his Swiss army knife, compass, flashlight, binoculars, whistle, canteen, steel eating utensils and the desired sleeping bag.

The plan had negative reinforcements as well. Helen told Anthony that two of her friends had promised they would be available to drive Anthony to school, whether he was dressed or not, allowing Helen to get to work on time. If Anthony was not ready when the friend arrived, he would have to get dressed in her car on the way to school. Helen pointed out that she may also have to talk with his principal, who might have to help with Anthony when he arrived at school—dressed or undressed. Therefore, Anthony had a choice.

This came as a shock to Anthony. He had become used to his morning routine and was almost oblivious to the impact it had on his mother and his younger sister. As it turned out, Helen never needed to call on her friends, and Anthony never needed to get into the car in his pajamas. He embraced the new routine, as he knew his mother would do exactly as she had said. Helen stopped the nagging and coaxing. She was now a woman of action!

Ideas to reshape difficult after-school behaviors

Understand the problem.

Controlling overloaded feelings at school is difficult for many students battling mood troubles, anxiety, impulsivity and/or learning issues. Trying to stay on task, listen, follow instructions and deal with friendships, let alone wrestle with literacy or numeric obstacles, extracts enormous amounts of energy. Many children are completely worn out by midafternoon. It is common for these children and young teens to hold it together until the moment they slide into the backseat of the family car. Then *wham!* Their frustration breaks loose, sometimes on a regular basis, with parents witnessing abuse, swearing, kicking of car seats and hurting and taunting of siblings.

Yet, there are ways to help these children and those in the firing line to navigate around this ugly situation. Begin by trying just one new creative solution to one bad afternoon habit. Keep it simple. When you feel as though you have managed one solution, introduce another idea to circumvent another harmful after-school habit.

Try a car pool and a snack.

A starting point may be to arrange for a friend or relative to pick up your child from school several days a week. Car pools work beautifully, because our children always behave better in the company of other adults and children. This does not mean your child will be less frustrated when he walks in the door once he reaches home, so arrange to be partially unavailable. Get busy in the garden or on a project in another room, and stay busy for half an hour or so. It's a fabulous idea to make sure you wear your headphones and listen to your favorite music while you keep busy. Everyone seems to know that when someone is listening to music, that person is less available. All you need to do is greet your child with a smile and let him know where the snack and drink are waiting. Healthy after-school snacks are vital. The bad mood that inspires awful after-school behavior may well be a product of too little lunch and no fluid intake throughout the day.

Switch from emotions to problem-solving.

The first thing some children do on arriving home is emotionally unload. They complain about mistreatment by their teachers and the unfairness they have faced with friends. They demand that their mothers listen to the litany of hardships life has dealt them. Thankfully, most parents have built-in equipment that detects the difference between whining and more serious situations that require adult intervention. Without discerning this difference, parents who participate in this emotional discharge are helping to develop a cycle of dependency.

They agreed and bought it. The teacher photocopied the CD's cover and cut it into 15 pieces, promising her student the new CD when he had collected all 15 pieces. The student could earn a piece for each lesson by responding positively, persisting with his work in class and not distracting other students. The idea worked well, because it helped the student change from behaving impulsively in the moment to developing a new, more productive rhythm. This strategy can easily be adapted for home use!

A simple idea curbed Noni's dinner-table talk.

Noni just wouldn't stop talking at the dinner table. As regular as clockwork, she gave an exhaustive commentary on what had happened to her throughout the day and detailed reasons for each of the events that had occurred. During the 30 minutes or so that her family sat at the table eating, 25 minutes of air time was commandeered by 11-year-old Noni.

But, a three-minute timer changed this forever!

With five people seated at the table, talk time needed to be more evenly divided. It was decided that all the family members were to be guaranteed a minimum of three minutes of uninterrupted talk time. They could ask questions of others, but the responses had to be brief. If they had nothing to say, they gave their three minutes to someone else. The new system helped Noni to regulate her talk time, gave her internal quiet so she could listen and ensured that others had an opportunity to speak. These days, Noni can still be long-winded, and she knows it. When her parents or brothers say, "Summarize it, Noni!" she now understands.

Candles were the key for Eliana at dinnertime.

Eliana was a much-loved but difficult-to-manage 13 year old, who walked to the beat of her own drum. From birth, she was clingy and demanding. Her cutting and scornful remarks often influenced the mood of the household and had tainted her relationship with her two younger sisters. Eliana had always demonstrated strong perfectionistic tendencies, avoiding risks and preferring to control. Her family had learned over the years that this was part of her nature. They understood that her personality style impeded her from easily appreciating and responding to the needs of others. Nevertheless, her moodiness and sharp tongue around dinnertime often resulted in conflict.

One of Eliana's few chores was to set the table. Even though it was a chore she had chosen, she usually had an excuse as to why she couldn't do it. Tension would escalate as Eliana found excuses that prevented her from arriving at the dinner table to begin the meal. Once she arrived, her mood simmered, and it wasn't long before she made an insulting remark about the food and found a reason for not wanting to eat. Family tension intensified, voices became raised and Eliana would eat selected morsels with her parent's insistence. This had long been the pattern.

To improve the dinnertime tempo, Eliana's parents implemented a new approach. They began calling Eliana 10 minutes before dinner was served. As she entered the kitchen, she would light the candle her

mother had provided and set the table. Then she returned to whatever she was doing, waiting to be called to dinner. The candle on the table remained lit. This, of course, was important, as her reward was attached to the number of candles eventually burned. When called for dinner, Eliana was expected to be at the table in a few minutes, and if she didn't arrive, her mother blew out the candle. Eliana had always been a picky eater. Years of experience had taught her parents not to force the issue, but instead, to negotiate a reasonable amount for her to eat. Sometimes she would say, "You know I hate" Using the new scheme, the candle would be blown out. As soon as Eliana apologized or checked herself, the candle was lit again, but she had lost valuable burning time. As Eliana was mindful of the candle burning, she spent more time at the table eating and positively relating to her family. Once she had eaten, she would blow out the candle and leave the table.

When Eliana had burned her way through two tea candles, she achieved a pre-negotiated incentive. (Each tea candle burned for about six hours, so using this system meant she achieved a reward in about three weeks.) She negotiated a music CD, as this was an item she would not normally receive. This approach successfully underpinned new expectations and routines during mealtime. It redirected Eliana's habitually negative responses and reshaped them into more cooperative ones. The candle no longer burns, but her parents continue to buy her a CD from time to time, because they appreciate the changes she continues to make.

Ideas to help with evening organization

The quality of evening organization is what determines the success of the morning routine. Here's a checklist of nighttime approaches favored by some families to help get their children off to a smooth start in the morning.

- Use picture prompts to keep children on track. Try using My Evening Checklist provided at the end of the chapter.

- Have the children finish their homework early. This reduces the likelihood of frayed tempers, which more often occur when children are pressured by homework late in the evening. Being proactive is much easier than trying to catch up.

- School uniforms are a bonus! They can be thrown on with just a change of socks and undies. However, as school uniforms are not a part of many children's wardrobes, it's wise to organize their clothes the night before. Lay everything out, ready to throw on in the morning.

- Ask children to take baths or showers and wash their hair in the evening, so these activities won't take up precious morning time. Then, all they need to do in the morning is get dressed, eat, wash up and brush their teeth.

- Pack lunches in the evening, if possible. At least plan what you will fix, and have everything ready. If you haven't time at night, or if certain ingredients need to stay refrigerated, leave the lunch boxes open on the kitchen table, and make this one of the first jobs you or the children attend to in the morning. Set up reminders!

- Make sure belongings (especially homework, teacher notes and assignment books) are in schoolbags, and the bags are placed at the usual spot before bedtime. That way, they can just be grabbed in the morning. By the time children reach second grade, most parents expect them to be able to independently pack their schoolbags. Naturally, some may require a little closer supervision until the habit is automatically incorporated into the routine. Set up reminders to help out.

- Families pushed for time in the mornings often plan what is required for breakfast the evening before. It may seem extreme, but a number of families ask their children to set their places at the table and arrange the things they will need the next morning for breakfast as a part of their evening obligations. In some cases it's a good idea, because the children are psychologically cued up for a secure start. They know what they are going to eat and drink for breakfast and have a mindset to do it.

- Once the evening routine is complete, it's time to relax. Getting the less appealing jobs done and out of the way is motivational. Be sure to build some free time into the schedule. For your children, this time may translate into watching television, making a phone call or two, playing a computer game, reading or doing another activity that they enjoy. Also bear in mind that children and teens who can watch television, make phone calls, play computer games and do whatever they want whenever they want won't find this incentive motivating at all. When children do not have expectations in place, you will find that you have lost your influence to persuade them to do what you want. Inadvertently, you've given away your leverage.

- At bedtime, check that your child's cell phone is placed in the agreed upon spot, rather than left in the bedroom. What a sensible practice!

- One of the best gifts for children as they start school is their own alarm clock, so they can set it to awaken themselves each school morning. Remind your child to set the alarm clock, even if you have to physically support this. In the early years, a child attaches novelty value to setting and using the alarm. As this routine becomes more firmly established, so does the valuable habit of independence.

Oh no, not the red card!

Phillipa found that reminding her young children to attend to tasks in the evenings had turned into nagging. Her children, as many do, had become so accustomed to her voice that they tuned her out and no longer effectively heard her. However, Phillipa was eminently resourceful and hit on a creative solution. She began by making a set of four cards—three with tasks drawn on them and one red card.

Their family routine was to watch a favorite television program together after dinner. Following this, the children knew they needed to get organized for bed. As their show finished, Phillipa would turn off the television and display the four cards, waving her hand flamboyantly, just as a TV game show host might do. Her comic quality always received laughs and set the children up to begin their tasks in a cooperative spirit. A little later, if someone wandered back into the family room to ask Phillipa a trivial question, she would hold up one of the cards, point to the task they should be attending to, turn away and go about her business. Occasionally, she would motion a child to her, write the chore he should be attending to on a little sticky note and press it onto his clothing. No words were exchanged, but the message was clear. Twenty minutes before her children were expected to be in bed and reading, she would wander about, deliberately displaying all four cards. It was a final reminder. The children knew the significance of this, because at eight o'clock (the designated bedtime), she would walk up to anybody with unfinished business and simply hold up the red card.

Earning a red card meant suffering a consequence with some bite to it. Her children respected Phillipa's wicked sense of humor and the creative consistency of her consequences. Truth be known, Phillipa's ingenious mind worked overtime creating bothersome, but appropriate, consequences for those who were occasionally red carded! Endless consequences ranged from dropping her children off late or picking them up early from events, friends' houses or parties to Phillipa refusing to drive them anywhere. Phillipa's children are now young adults, and they speak ever so fondly of her behavior management antics throughout their childhood.

Ideas for bedtime and going to sleep

What is a reasonable bedtime for your child? First, ask around and compare notes with other parents. It's worthwhile. This gives you a chance to find out what others are doing and how they are working the systems they have put in place. It allows you to compare, be challenged and determine whether what you have been doing is of benefit to your child and family.

Stop and think, *"What is my child like in the morning?"* Sluggish, irritable, confused? If your child is basically healthy but is sluggish, irritable or confused most mornings, then assume that bedtime is too late. Is your child, on average, receiving a little over nine hours of sleep most nights? This is what most sleep experts believe children and teenagers need. Sleep is brain food, and we know that those who consistently don't get enough sleep build up a massive, debilitating

sleep debt that negatively affects the brain. Bedtime should always be open to review, but common sense says it needs to be linked to morning efficiency.

A few guiding principles about bedtime and going to sleep are worth knowing. Recent research has revealed an emerging problem for teenagers—especially girls—who send and receive phone text messages throughout the evening and late into the night. The facts are plain. We now know that over-stimulation from electronic media such as computer games, e-mails, chat rooms, phone calls, text messages and television late into the night is responsible for disturbing the sleep patterns of many young people. Those who don't get enough sleep are not only grumpier and more prone to feeling depressed, but are not likely to concentrate and learn as well. Interestingly, new investigations indicate that long-term memory is consolidated during the dream-time phase of sleep, or REM sleep. This of course makes the issue of how much sleep one receives a critical factor, because without enough sleep, well-being and day-to-day performance are at risk.

Develop a bedtime routine.

Never lose sight of the importance of the bedtime routine: putting clothes in the laundry basket, bathing or showering, watching the usual television program, preparing clothes for the next day, making sure the lunch box is organized and homework is packed in the schoolbag, brushing teeth, giving and receiving good-night kisses, setting the alarm, listening to a bedtime story or having some quiet reading time until lights out. Working through the same series of steps each evening, at the same time, sends a series of powerful time-place cues to one's brain. These cues help all of us to begin to switch down, lower our activity level and prepare for sleep. Most children rely on parents to orchestrate this routine. In particular, this consistent patterning is essential for those who have difficulty getting into bed and falling asleep. They need dependable, explicit bedtime cuing. They rely on it—and may continue to do so as adults.

Time trading helped Matt's nighttime wanderings.

Matt was a talented nine-year-old cellist determined to follow in his father's musical footsteps. Academically, he was bright, and he also showed impressive abilities in sports. His spirited nature caused bedtime difficulties that had persisted for years. Matt's parents would tuck him into bed at what seemed an appropriate bedtime, kiss him goodnight, and then find him in and out of his bed over the next two hours.

He had a room to himself, but he would tiptoe into his younger sister's room, go to the bathroom, get a drink, sneak onto the computer or find a vantage point where he could secretly watch or listen to the television. The only way Matt's parents could ensure he would stay in bed and give in to falling asleep was to guard the hallway.

This long-entrenched pattern changed quickly once 'time trading' was introduced. (A Time-Trading Manager clock is provided at the end of the chapter.) Matt's parents explained that each time he was

discovered out of bed after lights out, the time-trading clock would be advanced by 10 minutes, and they would use that amount of time to inconvenience him the next day. The clock would be reset each night, but once time was lost, it could not be won back. In essence, it became Matt's choice to trade his time to his mother and father, and then they could do what they liked with it. The time-trading consequences included taking the accumulated time away from time spent playing his handheld computer game, playing on his PC and viewing television. They might also include deliberately making Matt late for his beloved midweek basketball or ensuring he was delivered late to his friend's after school or picked up a few inconvenient minutes earlier from enjoyable activities.

His parents realized the difficulty Matt faced in suddenly extinguishing this old habit, so they asked what incentives might help him stay in his bed at night. Together they decided that by having a CD player on Matt's bedside table, he could listen to a story or music as he lay in bed. This gave him something to keep him there. If over the next six weeks his parents saw a change (which didn't have to be perfect), then Matt would receive a small tropical aquarium for his bedroom. This had previously been discussed. It was an expensive acquisition, and Matt was keen to earn it.

In Matt's case, bedtime pilgrimages ceased surprisingly fast. His clever parents gradually adapted the concept of time trading to alleviate other difficulties they ran across—not just for Matt, but for his younger sister as well!

Alex's falling-to-sleep troubles drifted away.

Nine-year-old Alex managed to cram at least 70 minutes into every hour of the day. So for good reasons, his parents affectionately nicknamed him Mr. Speedy. High energy levels and over-activity delivered distinct advantages. Alex was a doer. He played three competitive sports and had been awarded a string of trophies and medals. He enjoyed loyal friendships and adored building and renovating his clubhouse, his passionate pastime.

However, his over-supply of energy made it difficult for him to settle down and drift off to sleep at night, even though his parents recognized he needed less sleep than most and allowed a later bedtime. His usual pattern was to lie for a few minutes waiting for sleep to arrive. After 5 or 10 minutes, he would become disheartened and flick on his light and start to play or leave his bedroom to get a drink, go to the bathroom or have a chat with his parents. Alex had developed a mindset that he had no other options.

Quite accidentally, Alex and his father stumbled onto an idea that changed Alex's bedtime troubles. One afternoon while his father was recording music, Alex decided to help him. Before they knew it, they had spent an hour creating a super-action hero story, where Alex and his father were featured together on CD as the world's greatest super heroes and, in disguised voices, were also the most diabolical villains the world had ever known! The story evolved, gathering its own momentum, and eventually they saved the world by defeating the wicked villains. The dialogue was punctuated with music to heighten the gravity of events. They had great fun making it together, rolling on the floor and laughing until their stomachs hurt.

Later that night, Alex wanted to listen to the CD as he lay in bed waiting to fall asleep—and he was asleep well before it finished. Alex no longer dreaded going to bed, thinking he'd lie awake for hours. Instead, he now enjoyed listening to one of his wacky CDs. Alex and his father created more stories together, and occasionally his father would surprise Alex with one or two he had made alone.

"I can't go to sleep—I'm scared!"

Sometimes a good dose of ingenuity does the trick against the evil forces of bedtime worry! Increasingly, Jack was experiencing trouble settling into bed and drifting off to sleep. Yet, nothing in Jack's life seemed to have changed. Bedtime, the home routine, school life and friendships remained constant. Then one evening as Jack's mother tucked him into bed and went to kiss him goodnight, he grabbed her hand and pleaded for her to stay longer. She decided it was time to ask directly what the problem was. "Jack, you've been doing this for the last couple of weeks. What's wrong?" His eyes darted about the room. In a hushed voice, he explained that he was worried about monsters. His mother asked where they came from, what they looked like and what they wanted. Jack was able to answer these questions. After all, he had notched up many hours lying in bed worrying about them over the past weeks. "They're not in here, Mom. They come down the hallway when the lights go out and it's quiet. I hear them." Jack's mom whispered that she had experienced the same problem when she was Jack's age. She suggested they use the same trick her mother had used for her.

Now as Jack prepares for bed, he and his parents lay their dirty socks end to end across Jack's bedroom doorway. Why? Because these monsters hate the smell of stinky socks! And, it had long been a family joke that Jack's father's socks always smelled the worst. So his socks were put at the front line of defense. This simple, creative solution gave Jack peace of mind and bought some time while he grew through this phase.

Jonathon decided to run his worries away.

Jon's parents resorted to an 'outside-the-box' solution to help him settle down at night. They encouraged him to take a two-mile jog at nine o'clock in the evening. Even though he finished his homework early and had plenty of opportunity to unwind, he found it difficult to settle down and go to sleep. Often, after he had showered and was already in his pajamas, he had an urge to run his worries away!

Jonathan was a worrier. He was a very bright, serious-minded 13-year-old, prone to anxiety and perfectionism. When he first asked to start running late in the evening, his parents worried that it was unsafe— and knew this was not the sort of activity other parents encouraged their children to do. To their credit, they recognized Jonathan's differences, and it was Jonathan who decided that running late in the evening seemed to help. Living on a large block helped to ensure his safety. These days, Jonathan throws on his track suit and running shoes, grabs the cell phone and runs for a half hour. By allowing themselves to think creatively, Jonathon's parents provided him with a way to work off his energy and approach sleep more easily.

Sleep talk to your child.

This simple, calming approach yields surprising benefits for some children. Eight-year-old Jon went through stages when he worried about his performance at school. He was a delightful soul but battled complex learning difficulties. Naturally these impacted his confidence, friendships, academic performance and motivation. Later in the evening, after he had been asleep for an hour or so, his parents would hear Jon gnashing his teeth and muttering. He remained asleep, but it was a restless sleep. To alleviate this, his mother or father slipped quietly into his bedroom and sat on his bed. While Jon continued to sleep, they rubbed his back for five minutes or so, offering reassuring sleep talk.

Their affirming statements included:

"You are doing well at school. Your teacher says this too. She knows that you learn differently, and that is fine."

"You have great talents. It's you who makes the best models. It's you who wins the swimming trophies. It's you who makes us all laugh with your magic tricks."

"Do you remember when you found the big crab at the beach? Everyone else had given up. You wouldn't—you stuck with it!"

"You are a beautiful boy and have so many friends and people who love you. There are"

"Remember to look forward to"

Following several nights of healthy sleep talk, Jon's periods of restlessness and gnashing of teeth always ceased. In an almost inexplicable way, it seemed to have a more inspiring result than having a direct conversation with Jon about the problems he faced and how he felt.

What matters most when tackling home trouble spots?

This brings us to the close of a chapter designed to beat, or at least relieve, many of the typical home trouble spots. The aim has been to present a selection of ideas that are likely to help you introduce stronger structures and routines and more cooperative patterns of interaction. My advice is to experiment with the ideas you think will work most easily with your child. Select one idea at a time, develop it so it's working and gradually expand your repertoire by introducing another new idea. Approaches can always be reworked or remodeled as new challenges emerge, and never underestimate the power of engagement that pure novelty possesses! Your creative planning and ingenuity will result in your child's old, unsuccessful patterns of behavior being replaced with new, improved ones. Finally, whether you are

attempting to improve your child's organization, increase contributions around the house, lift after-school moods or get your child to settle down at night, keep in mind that the quantity of improvement you want is linked to the quality of interaction you have with your child. This is what matters most.

my morning checklist

name_____

Color in the things you must do each school morning. Keep your checklist in a place where you can see it, and check off what you have done.

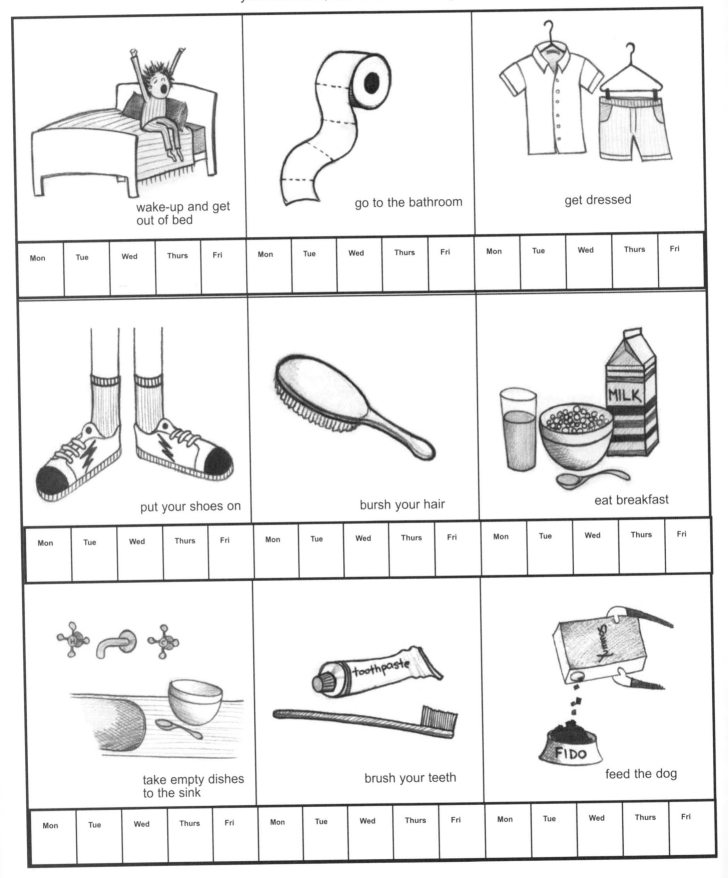

	wake-up and get out of bed						go to the bathroom						get dressed			
Mon	Tue	Wed	Thurs	Fri	Mon	Tue	Wed	Thurs	Fri	Mon	Tue	Wed	Thurs	Fri		

	put your shoes on						bursh your hair						eat breakfast			
Mon	Tue	Wed	Thurs	Fri	Mon	Tue	Wed	Thurs	Fri	Mon	Tue	Wed	Thurs	Fri		

	take empty dishes to the sink						brush your teeth						feed the dog			
Mon	Tue	Wed	Thurs	Fri	Mon	Tue	Wed	Thurs	Fri	Mon	Tue	Wed	Thurs	Fri		

name_____

staying on track with my dragon chart

Mon	○	○	○
Tues	○	○	○
Wed	○	○	○
Thur	○	○	○
Fri	○	○	○

When you are trying to swap an old behavior with a new, better one your dragon chart can help you to stay excited about your goal! Each time you do it; in the morning, in the afternoon and in the evening, color in a spot.

My dragon chart goal is_____

Reminders mom and dad can use to help me reach my goal are

My special reward for coloring in _____ or more circles in a week is

My extra special reward for achieving my goal in 4 weeks is

name_____

staying on track
with my duck chart

Monday

Tuesday Thursday Saturday

Wednesday Friday Sunday

When you are trying to swap an old behavior with a new, better one your duck chart can help you to stay excited about your goal! Each time you do it; in the morning, in the after-noon (or the evening), color in a duck.

My duck chart goal is _____

Reminders mom/dad can use to help me are

My special reward for coloring in 11 or more ducks for the week is

My 'super' special reward for achieving my goal for 4 weeks is

my happy face collector

Talk to your mom or dad about a helpful behavior they would like to see more of. Whenever they see this behavior a happy face is placed on the grid. If you are uncooperative a sad face is drawn.

Time of the day to start

Time of the day to finish

The helpful behaviors that I need to show are

When the chart is filled in with more happy faces than sad faces my reward will be

my evening checklist

name_____

Color in the pictures of what you must do each evening.
Keep your checklist is a place where you can see it and
check off the item when you have done it.

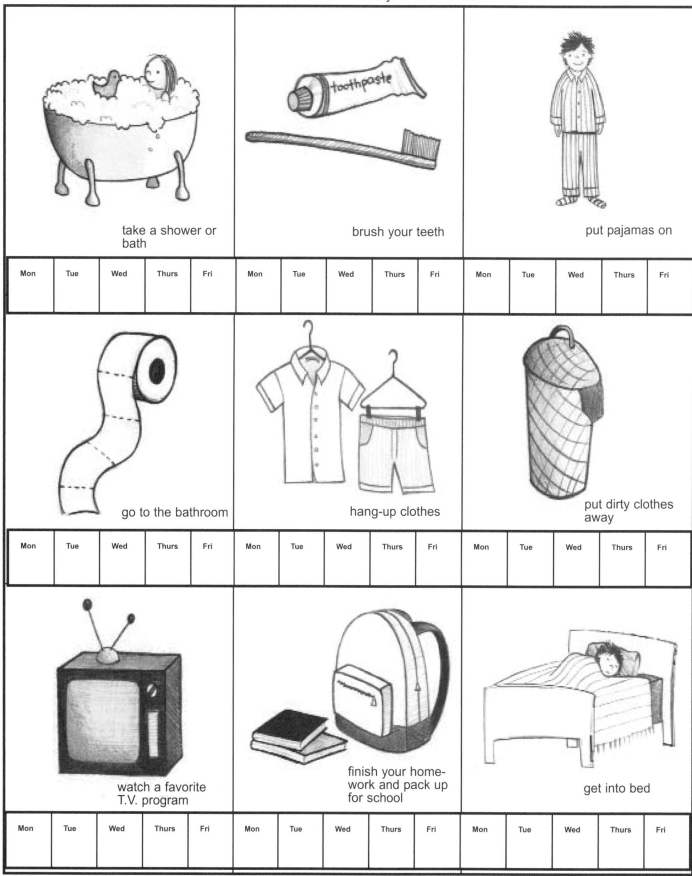

take a shower or bath

Mon	Tue	Wed	Thurs	Fri

brush your teeth

Mon	Tue	Wed	Thurs	Fri

put pajamas on

Mon	Tue	Wed	Thurs	Fri

go to the bathroom

Mon	Tue	Wed	Thurs	Fri

hang-up clothes

Mon	Tue	Wed	Thurs	Fri

put dirty clothes away

Mon	Tue	Wed	Thurs	Fri

watch a favorite T.V. program

Mon	Tue	Wed	Thurs	Fri

finish your home-work and pack up for school

Mon	Tue	Wed	Thurs	Fri

get into bed

Mon	Tue	Wed	Thurs	Fri

name_____

time trading manager

Once you go to bed and the lights are switched off, then each time you get out of bed or call out wanting something, the hand on the 'Time Trading Manager' is moved forwards by ten minutes.

Next day mom or dad can use the amount of time on the clock to cut short activities that you like to do; computer games, television, telephone calls, playing with friends, dropping you off late at sport, anything at all. The clock is always reset each night.

Choose the hand you like best. You can color it if you want.
Then cut it out and with a split pin attach it to the "Time Trading Clock"

Chapter 5

Friendships and Bullying

Creating friendships

The kinds of friends and relationships your children develop when they are young have a lot to say about how they will behave, the type of people they will become and the sorts of relationships they will seek later in life. As a parent, you provide the simple, everyday influences that contribute most to how your children feel about themselves and how they feel about others.

A healthy beginning is to examine your own attitude on the topic of friendship. Think about your style of friendship building. How do you do it? What works for you? Do other adults do it the same way as you? Are there similarities in the way your child's friendships and your own friendships work? Some parents believe their child needs a best friend, because they had one, and they hold precious memories of growing up with a best friend. Yet the truth is that children's friendships are truly dynamic, impetuous and ever-changing. Leading children to expect they must have a best friend or to believe that most children have a best friend is a destructive lie. Of far greater value is to encourage children to see the natural fluidity of relationships—to listen, participate, express their feelings to their friends, enjoy relationships and accept the inevitable changes. As we all know, little else is more certain than changes in friendships!

Quite often, I meet intelligent, caring parents who are genuinely troubled by their child's frail friendship-making abilities. They explain that their child floats between groups, appears to socialize on the edge of a group and is rarely invited to outings, sleepovers and parties, which leaves the child feeling unsatisfied. I frequently hear, "All I want is for my child to be happy."

After getting to know these children, making school visits to observe them and the other children with whom they associate and speaking with their teachers, it unfolds that these children are actually doing relatively well and are reasonably happy. Often they may not be well connected or popular, but they are interacting at a level that's comfortable for them and that they've consciously chosen. Also, to their credit, they usually have a fairly well developed understanding of the personalities of others and the nature of the groups within which they interact, and they know exactly how the social pecking order works. Sometimes these children are more aware of their circumstances than their parents. They know that, given the mix of children in their own class, they just don't have much to choose from. They make a conscious decision to stay safe and not get too involved with their particular school social group.

Despite the finest of teachers' intentions, school is not always the best place to find friendship for all children, and this is especially so for the group of children who are the primary focus of this book. Their impulsiveness, emotionalism, timidity or dogmatic natures can get in the way of building healthy and meaningful friendships. Some endlessly barge into groups and disrupt the play of peers; then when checked, they explode. Others find it difficult to be patient, to listen, to accept the opinions of friends and to take turns. At the opposite end of the continuum are those who are agonizingly shy. Initiating, let alone maintaining, a relationship is extraordinarily difficult. To survive the highly social rigors that school presents, these children may spend recess and lunch sitting on a bench, intently reading a novel. Sadly, this instinctive survival behavior draws further attention to the social awkwardness with which they wrestle. They continue to be different, look different and remain excluded. Parents often express their sorrow as they explain that the only friends their children have at school are those who display similar problems. The parents realize that because their children constantly fail to meet the expectations of their peers, they are increasingly criticized and excluded. It is not uncommon to see children in this group suffer dreadful isolation and attract hurtful taunts. This, along with repeated bouts of bullying, can result in loss of confidence, sadness, school refusal and even depression.

Without doubt, there are times when many children struggle to make and maintain friendships. This is when the experienced and subtle guidance of parents is required. By encouraging your child to participate within a more accepting group, friendship connections can at least start to normalize. After all, our own experience tells us that an accepting group is a safe practice ground for children to watch, listen and learn the skills required for friendships.

Here are a few down-to-earth ideas parents can use to progressively steer their children towards building more emotionally satisfying relationships.

"Mom, can I have a friend over?"

As much as some children really want friends over to play, their parents simply dread it! Bitter experience has taught them that this intimate play situation seems to expose their child's ill-equipped social skills. Having a friend over to play more often raises the potential to damage friendships rather than build them. Typically, when the friend arrives, the host becomes overexcited and silly or gets 'stage fright' and forgets the basic activities he thought he would share. Quickly, they both become disgruntled and bored. Pregnant pauses in conversations develop, and two lost souls wander aimlessly about the house. Events stagger from bad to worse. Then, the inevitable questions arise. "Mom, where's my thingamajig that I use to play 'copters?" You know it has been lost for weeks. "Mom, can we go over to the park?" You know the park has always been out of bounds. In desperation, the children switch on the computer and play a computer game. Unobtrusively, you observe your child with the controls constantly in hand, explaining the computer game but completely absorbed by it. Within a few minutes the friend has disengaged, and the idea of having a friend over to play has seriously soured.

Solutions are at hand! Start by changing the usual unsuccessful pattern to plans with purposeful structures.

Plan a short activity at home after school.

Arrange something for your child and the friend to eat and drink. Guide them towards watching a television program or a short video or DVD, and then take the friend home. Work on creating a short, structured and enjoyable playtime.

Head off to the park.

After arriving home, walk or drive your child and friend to the store. Buy them something to eat or drink, and visit a nearby park, bike park, skate park or playground for 30 minutes. Then take the friend home. Keep it short, sweet and memorable!

Go to the local shops.

Stop by the local shopping mall. Depending on their ages, arrange for the children to have a drink and do a little window shopping. Organize a visit to several stores of interest, such as the bike shop, pet shop or bookstore, and select a time and place to meet when the outing has ended and it's time to take the friend home.

Venture a little farther away.

Either after school or on a weekend, take your child and a friend to a place they both will enjoy, such as the swim center, the beach, the BMX track, a place to climb on the rocks or hunt frogs—or anywhere activity is structured and purposeful. Pack a snack or lunch, and be sure

to tell the children their play has to be brief. It's surprising how quickly they'll find many interesting things to do when time is at a premium.

Try a barbecue and a DVD; then send the friend home!

This obvious structure guarantees a win for all. Adult and sibling involvement can help regulate the situation so it's a thoroughly enjoyable experience.

Organize a cookout at home after school.

Set up a visit at home so your child and a friend can cook something and eat together; then send the friend home.

Arrange for the children to practice a sport.

Practicing sports is a good excuse for fun and friendship. Invite your child's friend to practice a sport that interests them both. This may take place in the backyard, at the local pool or on the local basketball or tennis court. Sports make it easy to structure a time for your child and a friend to practice their interests together.

It's worth taking the time to sit with your child, family, extended family and friends and brainstorm the sorts of activities that can be structured without too much energy. Similarly, use the same purposeful planning for sleepovers. It makes sense not to begin by having friends over for long periods, but to wait until the one-hour visits have become successful. Be mindful that younger children require greater direction. Older children are likely to resent intervention that's too obvious and generally respond best to less obtrusive structuring. Nevertheless, good planning makes winning possible for everyone!

Opportunities to develop friendships outside of school

As mentioned earlier in this chapter, for those children with unusual personality styles and self-regulatory problems, the socially fluid school environment can be wearing. Finding friendship can be difficult. For these children and teens, their best friendships and social connections often initiate and grow outside of school, where they are able to seize on a natural interest and find satisfaction in it. When this occurs, the emotional balance is immediately tipped in their favor as they find acceptance. Occasionally, these interests lead on to future career paths.

Parents often look towards such organizations as:

- Scouts
- YMCA Adventure Guides
- computer groups
- collecting groups
- science clubs

- chess clubs
- radio-controlled car clubs
- bowling clubs
- rock and mineral clubs
- backgammon clubs
- callisthenic clubs
- athletic clubs
- book clubs
- dart clubs
- historical reenactment clubs
- flying and gliding clubs
- model airplane clubs
- rowing clubs
- scuba diving clubs
- band and orchestra groups
- youth groups
- rock-climbing groups
- doll and/or antique collectible clubs
- hiking clubs
- various sporting groups
- model railway clubs
- photography clubs
- genealogy associations
- gardening clubs
- astronomical societies
- car clubs
- swimming clubs
- fishing clubs
- theater groups or drama classes
- dance groups or classes
- bird clubs
- choir groups
- cat clubs
- 4-H club
- BMX club
- church groups
- tai chi clubs
- karate clubs

A myriad of groups within the local community are worth exploring. The best place to start is with your city's government, which often has a community relations department that can be helpful with this sort of information. Try searching the Yellow Pages (beginning with clubs), or try a Web search.

Never underestimate the potential benefits these community clubs and associations can offer. The best situations are usually semi-organized by adults. They foster friendship, develop interests and serve as safe havens for children and adolescents to develop their 'emotional muscles.' To give some idea of the vital role community clubs and associations can play, a study by Hedley & Young (2003) found the incidence of depressive symptoms in young teenagers with Asperger Syndrome running at an overwhelming 25 percent. Their recommendation to combat sadness and depression and improve general well-being was to encourage young individuals to participate in activities and groups that foster acceptance. Parents often ask about the value of directing their children to join sports as a means of increasing friendships. In my experience, this is questionable. For children who don't have well-developed physical abilities or find losing too much to bear, the pressure cooker atmosphere of competition can be disastrous.

Formal social-skill training programs

Sometimes children and teenagers find benefit from attending a formal social-skill training program, where they are explicitly taught how to solve social problems and behave in pro-social ways. Children and teens learn the skills required to establish and maintain friendships. They also learn ways to handle teasing, aggression, social isolation and peer rejection. The internationally recognized STOP THINK DO program is my preference. It links feelings to behavior and develops the idea of inserting thinking between feeling and reacting. This program develops self-control and communication skills at STOP, problem-solving skills at THINK and behavioral skills at DO *(www.stopthinkdo.com)*. Best outcomes are achieved with the continuing support of significant others such as parents, teachers and peers for maintenance and transfer of skills. In addition, research suggests that when children are relating well and behaving in friendly ways, learning outcomes improve.

Other well regarded programs that teach children and adolescents to understand more about themselves and social life and how to increase their resilience and friendship-building skills include:

Friends for Life program by Dr. Paula Barrett *(www.friendsinfo.net)*

Resourceful Adolescent Program *(www.rap.qut.edu.au)*

Circle Time *(www.inyahead.com.au)*

Look under Bookshop.

Cool Kids Program *(www.psy.mq.edu.au)*
Search the site for Cool Kids Program. Materials are available for mental health professionals, schools, parents and children.

Bounce Back Resiliency programs by Dr. Helen McGrath and Dr. Toni Noble *(www.bounceback.com.au)*

Improving your child's social connections and well-being

Teach and reteach rules for friendship.

It's surprising just how often coaching is required to highlight the rules of friendship. Children and young teens often need rules of friendship as recipes to follow. They soon discover that it is one thing to meet new people and successfully gain friends, but it requires quite another set of skills to maintain friendships. Even if the rules of friendship provide little more than basic skills to hang new behaviors on, their place is invaluable.

Rules for making friends

- Be brave; walk up and introduce yourself.
- Say your name, and look the person in the face.
- Smile!
- Ask the person about him- or herself.
- Listen to the answers.
- Talk about things you have in common.
- Be yourself. Avoid bragging or looking too cool.
- Sound and look kind.
- Think about what you say if you want to make a good impression.

Rules for keeping friends

- Just be nice to them. Care for their feelings.
- Include them in what you are doing. Share.
- Talk and listen. (Don't forget to listen!)
- Ask them things about themselves.
- Find out what they like and don't like.
- Sometimes do things together outside of school.
- Tell the person you are a friend.

- Give feedback about the things you enjoy with and about the person.
- Notice how the person looks or seem to feel, and ask, "What's wrong?" or "Are you okay?" when s/he seems out of sorts.
- Think before you speak. Uncaring comments put others off.
- Remember, friendship doesn't have to be perfect.

In her book, *The Circles,* Kerry Armstrong adds a delightful insight about how to deal with friendships. *The Circles* is a guide to help children and adults sort through their feelings about others. By placing people within concentric circles around ourselves, it is easier to see how important they are in our lives, how we feel about them and what we can do to feel better. Armstrong's book can be a real help in taking control of feelings about friendship hiccups and difficulties. *The Circles* is a small book containing a great idea. It's certainly worth a read.

Coach your child on how to say "I'm sorry."

Saying "I'm sorry" really does matter. "Sorry" can rescue lots of situations, yet so many find it difficult to say—even later, when they are feeling calmer.

During happier times, discuss what the word *sorry* means, when to use it and how it can be said. Have fun with your children, role-playing situations where "sorry" might be helpful. Try "sorry" with a smile, a touch, a wink, a handshake, a rub on the arm or a hug. Brainstorm a range of words and actions that mean or show that one is sorry. Point these situations out as they happen on television programs! Coach your child to understand that saying you're sorry isn't necessarily an admission of wrongdoing or guilt, and it may not always be accepted by another. More to the point, it is a powerful gesture to reduce resentment and allow the relationship to heal and grow.

Teach empathy, sympathy and compassion.

Teaching children and adolescents how to behave compassionately is helpful. Approaches include watching and discussing videos and DVDs or appropriate television sitcoms. You might also try role-playing or watching mock arguments. Discuss why individuals thought, felt and reacted in particular ways. This helps to stretch your child's empathy and compassion. Ask questions such as the following:

- Is this argument as straightforward (plain and simple) as it seems?
- Whose fault do you think it is?
- Who is wrong and who is right?
- Could both be right? Why?
- Are both a victim and a perpetrator (bad guy) involved?
- How does each person feel?
- How can you tell?

- What would you do to fix it?
- What would you say to him?
- What would you say to her?
- How would you look?
- What sort of voice would you use?

Some find it very difficult to show empathy, sympathy and compassion, even though they may feel it deeply. Yet these qualities rate highly on the list of those necessary for maintaining successful relationships. At the end of the day, if someone is able to show the right look, use the right words and behave empathically, they will pass the test with flying colors. This is why training at home is vital for some children.

Teaching children how to show empathetic behaviors is also likely to help them become more accepting of others. They begin to see that relationships are truly multidimensional and richly layered and that points of view can shift. Gradually, with input and support, children can be led to see that situations are rarely just right or wrong, fair or unfair, black or white.

A mentoring partnership might give your child an edge.

Adults repeatedly talk about significant others, coaches or mentors whose guidance and encouragement when they were young made a huge difference in how they felt about themselves. The mentor may have been a teacher, an older student, a school counselor or a principal; or mentoring may have taken place outside school through a friend, a university student, a neighbor and so on. What seems universal is that they felt their mentors liked them, believed in them and helped them to discover more about themselves.

Mentors can do something that parents cannot easily do. They can unemotionally mirror back events and ask questions that can be problematic for closely involved parents, such as:

- Why do you think that happened?
- Did your "fast feelings" get in the way?
- Was there another way you could have handled it?
- What may have happened if you had done it that way?
- What gives you the right to keep doing this when others don't?
- Let's work on one idea to help this situation.

A good mentor can also offer support for learning, such as helping to plan and structure assignments; providing reading, spelling and other academic interventions; and encouraging routines for improved organization. By depending on a mentor, children and teens can thrive. Together, they can build structures to improve routines, develop strategies to build friendships and find avenues to improve academic skills. As a consequence, the children's lives become

more predictable, allowing them to behave more steadily and harmoniously. Mentoring has provided many children with the impetus for greater success.

Teach your child body language.

Our body language gives others a great deal of information about us. Yet, many individuals are often unaware of what their looks and tone of voice, let alone their actions, may be implying. Unthoughtful body language can set a person up for victimization, failure and rejection. The ways in which we sit, stand, lean and use eye contact, facial expressions and tone of voice send persuasive messages to others. It helps to know the simple facts about social feedback skills when communicating. For example, maintaining eye contact suggests confidence and interest, and sitting up and leaning slightly forward while listening indicates a person is engaged in what is being said. On the other hand, mumbling and looking down expresses uncertainty, and folding one's arms gives the impression of low confidence, defensiveness, or even disinterest or disdain.

To improve your child's appreciation of body language, role-play body language, facial expressions and voice tone noticed in others, and act out disgruntled faces, surprised bodies, quizzical faces, embarrassed faces, sad bodies and so on. Ask your child to read the faces of others and guess what the other people might be feeling. Ask him to make the same face. This is a good time to introduce the idea of how a person needs to look and what he needs to say to get along with others and how this differs from situation to situation.

Also consider cell phone etiquette. How your child or teen uses a cell phone will make a world of difference in how others judge him or her. When should a cell phone be silenced or left somewhere else? Which situations are unsuitable for responding to a call? Pose a few hypothetical situations. For example, is it right to respond to a call from a friend about party plans when in the orthodontist's chair? What are the likely implications of sending offensive text messages to others? Play with these ideas, and alert your child to the potential pitfalls of this wonderful technology.

Bullying and how to deal with it

Over the last few years, researchers have collected enormous amounts of information about bullying. We now know that no kindergarten, school or college is free from bullying, and no student can be guaranteed safe from it. We also know that bullying is widespread in American schools. According to a 2001 survey funded by the National Institute of Child Health and Human Development (NICHD), more than 16 percent of U.S. school children said they had been bullied by other students during the current term.

The general profile of a bully is nearly impossible to define. Some bullies are obvious, hateful brutes, others are socially inept and some bully ever so sweetly to get their way. Research confirms that absenteeism is greater among those who are bullied. In addition, students being bullied were found to be associated with suicidal thoughts and attempts to harm themselves. As a response to counter bullying behaviors, plenty of policies and programs have been implemented in schools. While the media is always quick to pick up on, talk about and popularize these programs, unfortunately they have yielded only average improvements.

Countering bullying begins at home.

Naturally, it is not possible to isolate your children from bullying encounters, but it is possible to take a few practical steps to sharpen their awareness and responses to this unwanted behavior.

Teach your child what bullying behaviors are.

Teach that bullying is all about the manipulative overuse of power and that your child's response to it can reward the bully's behavior, deflate it or deflect it.

Explain what a bystander to bullying should do.

Always stress that bullying is unacceptable. An important part of changing the bullying culture is to educate your child that it is not acceptable to stand by and witness bullying without doing something about it. This doesn't mean that your child needs to put himself at risk, but it does mean he has a responsibility to intervene in some way, either directly or indirectly. This focus on the responsibility of the bystander is the new benchmark!

Help your child grow a 'thicker skin.'

Offering a humorous or quick, off-handed response to a bullying comment can go a long way to help a potential victim seem thick-skinned. Surprisingly, many children need training, retraining and rehearsal on how to do this. Above all else, teach your child not to immediately appear crestfallen in front of the teaser and not to over-personalize hurtful remarks. Remind the child about the concept of random comments. Random, impulsive comments just happen between children and young adolescents. It is not wise to overanalyze the comments. They should simply be dismissed.

I often ask children and teens whether they are "sponge kids" or "Teflon-coated kids." Sponge kids seem to absorb every upset or thoughtless comment, while Teflon-coated kids have a tough protection that allows unkind comments to slip off. "Don't wear your heart on your sleeve" is another useful expression to use and is a springboard into strategies to help keep overly sensitive children safe. In 2002, I coauthored a workbook and video titled *STOP and THINK Friendship Video Package (www.stopthinkdo.com)*. One aspect of this publication included a few basic anti-

teasing ideas for children. Here are several of my favorites, which you might like to share with your children:

Whatever!

Help your children rehearse two or three quick replies. Then, when they are put down by a teaser, they can roll their eyes and say something like: "Yeah, you're right!" "None of your business!" "Whatever!" "Takes one to know one!" Or, "Oooh la, la, la!" Then they should walk away.

There's a booger up your nose!

When somebody gets right into your child's personal space and is unfairly criticizing him, train him to bend down slightly and look up the nose of the aggressor. With his eyes fixed squarely on the teaser's nostrils, tell him to say, "Oh yuck. You've got a booger up your nose. It looks disgusting!" Then teach your child to walk away. This is a good deflecting technique.

You've got dog poo on your shoe!

Similarly, as somebody approaches your child determined to annoy or tease him, he can twitch his nose a little and look hard at the teaser's feet. Help him to rehearse shouting out, "I can't stay here! Something stinks! You've got dog poo on your shoe!" Then he should walk away.

The tease-proof shield

This can be a powerful skin-thickener for children with strong imaginations and thin skins. Help your child to practice surrounding himself with an imaginary tease-proof shield. The shield cannot be penetrated by hurtful words; they just bounce back at the bully and never reach your child's heart. Teach your child how to power up the shield with his determination. Help him practice maintaining a relaxed, smiling face as you deliver a barrage of mean words. With practice, this can become a very powerful defense.

A word of caution: These techniques are NOT recommended to promote the exchange of insults between children. They are simply a way to give an off-handed response to teasing and take back a little control. It is not wise to encourage a victimized child to deliver insults, especially if the child is being intimidated by a stronger person or group, as this will certainly be to your child's disadvantage.

Talk about what to do next if the response to bullying is not helping.

Often the best time to do this is in general conversation that is focused on the plight of someone else. This type of conversation not only alerts your child to how bullies present themselves and what your child needs to do to protect himself, but it also sends a signal to potential bullies that 'bully psychology' is now very clearly understood. Recent books such as *Queen Bees and*

Wannabes (2002) by Rosalind Wiseman and films such as *Mean Girls* (2004) have contributed to our understanding by popularizing the psychology behind bullying.

Talking about the bullying is an important step.

Encourage your child to talk about it if he is being bullied. He can talk to you, teachers, friends at school, friends outside of school, other trusted parents, a relative or a caregiver. Reinforce that this is not the same as tattling. Talking about bullying can result in dealing with this age-old social problem in a clever way.

First, carefully listen to the problem. Avoid rushing in and trying to fix it or blame someone. Listening sympathetically is a legitimate way to reduce the negative impact of bullying. Not only does listening help you to understand the situation, but it helps your child to clarify exactly what has been happening and what action might be appropriate to rectify the situation.

Reassure children that bullying is WRONG.

All children have a right to feel safe in the classroom, on the playground and at home. Let children know that their principal, teachers, friends and the community support this attitude. A number of excellent websites are available for children to learn how to cope with bullying. This may be a perfect time to investigate a few of the resources listed in the References section at the back of the book.

Remedy your child's position of powerlessness.

Allow your child to come up with ideas on how to deal with the difficulties. This includes considering what the child might need to do differently as well as ideas that might correct the bully's behavior. Emphasize that the bully may also need some help. Ideally, one or two of the child's ideas should be featured in a plan devised by the teacher or school to deal with the issue.

Approach the teacher, principal or school counselor.

Try to stay calm. It's natural to feel emotional, and it is very easy to say things that might damage an already delicate situation. Appreciate that it will take school staff time to gather the information and deal with it. Be gracious but resolute. Teachers and counselors will develop a written plan to help everyone recover and learn from the incident. They often follow this sort of procedure when constructing the plan:

1. First, the nature of the difficulty is defined and clarified. The severity of the problem will decide how the problem should be addressed.

2. An inventory is developed consisting of who is, or should be, involved (parents, teachers, a doctor, psychologist, school counselor, external professionals and so on) and in what capacity.

3. A decision is made on how the victim and bully are to be supported. The victim's spirits may be buoyed by assisting him to develop a network of sensitive peer confidants. The bully, on the other hand, may need support in order to learn how to interact in more acceptable ways.

4. The question of whether it is best for the victim and the bully to safely participate in a process of healing the difficulty is considered.

5. A way is found for the victim to be kept informed of what is happening. Frequently, schools respond suitably to bullying behavior, but the victim is unintentionally left out of the information loop. The victim then feels powerless and believes nothing has happened to rectify the situation. This cements the victim's fear that the bullying will happen again and the bully will continue to get away with it.

6. A set of procedures is devised so that all students involved know what to say and do to recover the situation.

7. Techniques are determined to increase the monitoring of both students' interactions, especially at play times. By doing this, progress can actually be measured.

8. Opportunities are developed for both students to check in with a teacher or counselor to monitor the situation and evaluate progress.

9. Sometimes, specialized help is required in the form of social skills training or assertiveness training. The victim may need to learn how to fit in and make friends, and the bully may need to learn how to use the need to control and lead in a more pro-social way.

10. A time is set to meet again to decide if the strategies put in place are helping.

What if the strategies are not helping?

If the bullying problem continues despite committed and thoughtful interventions, it is wise to consider a change of class, or perhaps a change of school. A popular myth asserts that students who have been bullied at one school will simply invite bullying at the next school. The evidence suggests that most students who have suffered bullying are not bullied in new situations.

I want to conclude this section by making a wildly obvious comment. That is, you can't make bullying go away by trying to ignore it. Yet, I am surprised by the number of students of various

ages who say that it is better to put up with bullying than to tell someone. The reason, they consistently say, is that telling makes matters worse. Once they tell, they face the unpredictable reaction from the bully, risk other students becoming involved, watch adults mishandle delicate matters and feel as though their powerlessness has even been intensified. Students repeatedly feel that most teachers and parents just don't appreciate the depth and complexity of the bullying that takes place, and even when they do, they usually haven't the time to counsel and support those involved or maintain the repairs they do manage to effect.

In believing this, our children offer us a real challenge. Their feelings about bullying and the inadequacy of how we often deal with it highlight the sophisticated and ever-changing nature of this menace. Without the development of a culture focused on improving ways to communicate and reconcile differences, school anti-bullying programs and ad hoc interventions will continue to deliver very ordinary levels of success. By teaching your child compassion and understanding, being consistent and persistent in your support and encouraging the use of reconciliation processes in your child's school, you can help create this kind of culture.

Chapter 6

Homework Solutions

Who wants homework?

Survey a few adults and ask about their memories of school homework. Most will roll their eyes and make a disparaging comment or two about the experience. Most have memories of boring exercises, repetitive worksheets, contracts, or worse still, projects that were supposed to polish their time-management skills. Years later, a few are able to convince themselves of the virtues that must have been ingeniously embedded in homework, but they admit it was difficult to appreciate this when they were seven, nine or 13 years of age. Let's be honest. The thought of tackling homework after a day at school is not exhilarating—especially when so many other distractions, interests and passions call to children.

Those parents who favor homework say it encourages good study habits and recaps the day's learning. They deem that the earlier students start the better. They also argue that secondary school students have too much work to be covered, thus making homework necessary. Those parents arguing against homework say it obstructs family life, contributes to family tensions, accelerates burnout and, because of its sedentary nature, is in part responsible for growing childhood obesity. They insist that the pressure of homework each night (as much as five or six hours in high school) makes it difficult for their children to lead healthy, balanced lives. It also can be argued that homework creates unfair advantages for students with reliable and structured home environments, strong parental support, their own rooms, desks, computers, rapid Internet connections and abundant software reference materials.

As for students, they generally fall into three categories. They either like homework, comply with it out of necessity or reject it.

What are parents and teachers saying about homework?

Current responses from parents about homework reveal the following opinions:

- "I think homework should only be completion work."

- "Even with busy lifestyles, homework must be accommodated every school night."

- "Parents need to know how to help, when to help and what to do when things go wrong."

- "Homework is expected, but please make it simple, basic and consolidating."

- "Homework is useless when set for no purpose."

- "It's unfair. Not all parents have the same time available to spend with their children."

- "Isn't family time important too? Children grow up too fast. Time is so precious."

- "Homework is hard to fit in. When we end up doing it, the kids are tired and at their worst."

- "Our child's teacher gives homework but rarely grades it. What's the point?"

- "Too often homework is a verbal instruction that gets confused."

- "I agree with homework, but I don't like it when I end up doing it for him."

- "Every week, it's the same old worksheets."

- "Homework tasks should match the child's abilities."

- "There's a theory that giving children homework will prepare them for homework in high school. That is rubbish. It is like saying hitting your head against a brick wall will prepare you for a migraine!"

As for teachers, many feel they are under pressure to provide homework even though they may question its value. Teachers reveal the following concerns and opinions:

- "Homework definitely improves the home and school partnership as well as the student's learning."

- "It's always hard to gauge exactly how much time my students will have to spend on their homework, as it varies so much from student to student."

- "It's difficult to vary homework so that it's seen as useful and stimulating to all students and parents."

- "How often should homework be given? I constantly wrestle with whether it is better to provide one task each night or run a weekly program."

- "Should I be falling into line with community expectations or actually leading my community?"

- "It's hard to determine whether what I'm offering is consistent with other grade-level teachers in the school."

- "Should I modify homework to reflect a student's developmental learning issues?"

- "How do I determine the level of support a student will receive from home? And, what am I expected to do if it is too little or too much?"

- "It should not be up to me to train parents how to do homework with their kids."

- "I'll be honest; I hate grading homework and I hate the damage it can have on my relationship with the student when it is not done."

The Homework Grid, an exciting initiative from Down Under

Very recently in Australia, leading educators have turned their attention to homework. This, in part, is being driven by the alarming fall in school retention rates, declining academic results (especially for boys) and difficulty in keeping students engaged with learning at school. There is a growing sense among parents and educators that we should be doing better with schooling and homework to meet the changing needs of our students, our families and our communities.

In an effort to make homework more relevant to students and families, the Homework Grid was created by staff at St. Augustine's Parish School, Salisbury, South Australia. It is an innovative attempt to 'circuit-break' the homework overload caused by teachers persistently assigning homework, often just for the sake of tradition or because they feel they are expected to do so. Educators and parents alike are questioning the significance of homework and considering options to improve its character.

The Homework Grid in brief

The concept of the Grid encourages optimistic family interactions. Many think it helps children become more involved or re-involved in family life. It also takes into account the diverse nature of after-school activities and permits time for children to pursue their own interests and learning. Grid activities ("cells") might include:

- physical pursuits (sports activities, hiking, family walks or outings)
- reading
- being read to
- reading to a family member
- housework or chores
- continuing an assignment or a contract (language, math or humanities)
- shopping
- playing a game with parents
- music practice
- researching on the computer
- talking to or teaching a parent something
- art
- meditation/relaxation/spiritual activity
- completing work left from a lesson
- cultural activities (such as visiting art galleries, museums or cultural centers, going to a concert or renting an educational movie)

Generally speaking, the grid is followed over a two-week cycle. In terms of time commitment, each cell represents approximately 15 to 20 minutes for elementary students and 30 minutes for middle school students. Time still exists for homework assigned by teachers and is built into the cells (e.g., continuing an assignment, reading, completing work left from a lesson, etc.). It is suggested that if formal homework requires parental assistance, then the work is better off being completed in class under the teacher's supervision.

The diversity of topics that comprise the cells is endless, and ideally, the activities offered within a grid reflect the age and interests of the students. For a more detailed explanation of each cell, how it can work and possible adaptations, I recommend you read Ian Lillico's small handbook

titled *Homework and the Homework Grid*, available through his website, *www.boysforward.com*. Despite the site's address, the ideas can be used for both boys and girls.

Up until quite recently, many of the attitudes surrounding homework had changed very little. Homework had become institutionalized and, as mentioned previously, followed a ritual of teachers providing regular homework exercises, often just for the sake of giving them. Educators and parents are now critically questioning the merits of traditional homework in contemporary society. The spark has been ignited, and there is no turning back. The sort of quality thinking and planning required to underpin homework is finally under the closest of scrutiny. The nature of homework has been redefined. Its new definition is rapidly catching the attention and praise of educators, school communities and families throughout Australia.

The Homework Grid presents us with wonderful potential to integrate contemporary family lifestyles with student engagement and learning. Already, a number of middle and high schools have surveyed their families for their opinions on homework, and as a response to community opinion, are beginning to implement the Homework Grid or aspects of it. However, a word of caution is offered here. Recent experiences have shown that the implementation of the Grid demands comprehensive consultation with parents and students as well as deep planning. Without this, the grid will quickly take on the trite, dull, unchallenging or forced dimensions of some traditional homework approaches. No matter where you place yourself in the great homework debate, the concept should be considered evolving, because whatever is considered perfect for today won't be thought of as state-of-the-art tomorrow.

Homework basics

Whether schools choose to engage the Homework Grid, maintain what they currently have or choose some sort of modification, parents will always have natural difficulties in managing a homework routine and their own expectations around it. Introducing common understandings among students, parents and teachers is vital if we really want homework to be as beneficial and harmonious as possible. With this in mind, a good starting point may be to consider the following homework basics for students, parents and teachers.

Homework basics for students

- Find a spot that works for you. The best places are in your bedroom or the study, or at the kitchen or dining room table. Work in the same place at the same time each day, so it becomes routine.

- Working in front of the television is not effective when it comes to thinking through a math problem, learning new spelling words or writing. However, if you have a picture or

a map to draw or something to color in, cut out or glue, then it is fine to work in front of the TV. Do the thinking parts first, though.

- Make a daily timetable, and display it in a visible place on the wall. Begin your homework early, so you can get it out of the way. A routine will help to balance homework and fun!

- If you do not do your homework, expect your teacher to ask you to do it during the school day. You may be asked to do it before or after school or during a fun time, such as recess or a reward time.

- Your homework does not have to be perfect.

- If you like to use the computer and it helps, talk to your teacher and parents about using it more often.

- When you don't understand a question, ask for help. Listen. Then let your mom or dad walk away. Never allow your parents (or older sibling) to do your homework for you. It won't take your teacher long to figure out what's happening.

- If you often leave school not knowing what to do or with the wrong books, ask your teacher to set up homework reminders to help you. Most teachers will be happy to help.

- It doesn't matter whether or not you like homework. Think of it as a way to practice doing something someone else wants you to do. This way of thinking is a skill.

- Figure out how you work best. Some students go to their homework spots and stay focused until they have finished. Others need to take short breaks between each part of the homework. Some need a snack and time to wind down after school. Others do their homework immediately after school. What suits you? Experiment and find out!

- NEVER let your mom or dad turn homework time into "Let me teach you how to do this," unless you want that to happen. If they think there is something they should teach you, arrange it for a different time.

- Sometimes homework looks as if it's going to be hard. Your first reaction might be to stop. Instead, think to yourself, "I'll read the instructions first. I'll do one thing at a time." Start by talking to yourself. Think out loud, if you need to, and think or talk your way through the first task.

- When you finish your homework, put it directly into your backpack or school bag. Then, go and have some fun!

- Homework basics for parents

- It's your child's homework. Allow your child to learn by experiencing the consequences at school of success, avoidance, disorganization or forgetfulness.

- Communicate with your child's teacher. It is important to know when assignments are due, and develop an arrangement to let the teacher know if the homework task was too difficult.

- Make homework a daily expectation. If it isn't important in your routine, then don't expect it to feature highly in your child's.

- Appeal to your child's natural strengths. If working on the computer is more engaging, arrange for your child to do as much homework as possible on the computer.

- Talk with the teacher and agree on modifications if necessary. While busywork is the icing on the cake for some children, for others it is just too much.

- Gradually guide your child to develop a logical pattern of thinking. For example, encourage the following pattern of work:

 1. Decide on the first task to be tackled. Estimate how long it should take, and periodically use the kitchen timer to check this out.

 2. Work at it for the estimated time.

 3. STOP.

 4. THINK. Was the goal achieved?

 5. If it was, great!

 6. If the goal was not achieved, think about why not and make the necessary adjustments.

 7. Decide on the next goal and return to work for 10 minutes.

- It is a parental responsibility to organize and maintain a place where pencils, pens, markers, lined and graph paper, glue stick, ruler, protractor and so on are kept. This reduces frustration and eliminates some avoidance tactics. It is also a parental responsibility to work out the best location for a child to tackle homework. The bedroom with a closed door is probably not a perfect place for the avoider, and the centrally located kitchen table in a busy household is not optimal for the easily distracted.

- Resist the temptation to sit and continuously work on homework together. Be available to answer a question, suggest an idea or demonstrate. Spend no more than two, five-minute periods every 25-minute block of time perched by your child. Otherwise, no matter how you justify your action, you are drip-feeding your child with a powerful NO CONFIDENCE message. It says: "I don't trust you to think your way through your homework without me."

- Children need to know that their homework efforts are valued. Assure them in a positive way that you recognize their efforts.

Homework basics for teachers

- At the start of each year, go back to basics. Set up formal meetings with parents, accompanied by their children, and explain your homework approach. Explicitly teach parents how to work with their children, how to complement your approach and how to best communicate with you.

- If, after a term, a small group of students and families continue to experience difficulties, then follow up with workshops targeting these families.

- Know why you give homework. If your own opinion is philosophically different from the school's homework policy, try not to compromise your delivery and follow-up.

- Explain to parents that homework time should not be a "Let me teach you how to do this" session. Homework has a different agenda, which supports independence. Make a strong distinction between the two.

- Expect homework to be done. If it is not, follow up with the student the next day. The follow-up should occur during your most convenient time and the student's most inconvenient time. Refrain from doubling up on homework with missed assignments, as it often compounds the difficulty.

- Be flexible. Modify tasks. Allow students to complete homework on the computer, as this keeps the work tidy and can be a support for students with learning and concentration difficulties. Allow students to talk their homework onto an audiotape or a videotape or to use Dragon NaturallySpeaking software to turn their speech into text. Teach parents how to transcribe for their children from time to time.

- Students with learning difficulties, attention deficit, home problems and emotional challenges benefit from modified homework. Shorten homework tasks to correspond with their capacities and home opportunities. Be conscious of necessary core-curriculum tasks versus peripheral busywork.

- Always follow up on homework with a comment, sticker, mark or grade. If it's worth undertaking, it's worth acknowledging.

- Projects, or research-based homework assignments that run over lengthy periods, are frequent points of contention. Oftentimes, outrageous parental involvement is required to manage time, inspire, nag, research, teach, transcribe, type, draw, color, cut and glue. Start by teaching students the individual components involved in tackling this sort of work: researching materials, pulling together and organizing the information, managing time and presenting the final product. These are complex tasks that require specialized, formal teaching over time. It is best done in the classroom, not at home.

- Teach students a few homework tricks. Tell them they can color busywork by the TV. This way, the job is less tedious. Teach students how to play 'self-bargaining' games of making sure homework is finished before their favorite TV program.

- Avoid grabbing at just anything for homework if nothing is planned. It's better to give students a rest than present them with something that is confusing, time-wasting or annoying to parents.

- Do not accept homework that shows heavy-duty parental input. Go to the heart of the matter and make an appointment with the parents. Teach them new strategies. Stop this enabling early, as it is taxing for parents, demeaning for students and frustrating for teachers.

- Set up efficient ways to communicate with parents on a regular basis (e.g., class newsletters, e-mails or phone calls), so they know when assignments are due. Provide printed task sheets and progress checklists to help with time management.

- If you have to choose, reward effort at the expense of quality.

- Teach students how to record their homework tasks. Set up creative ways to maximize their chances of knowing what they have to do and the books they need. Explore different strategies for challenged students, such as: setting up a buddy system; e-mailing homework; leaving homework messages on their answering machines or cell phones; mailing assignments home on the Friday before the week commences; slipping homework sheets into school bags; or playing "show me your books and assignment book on the way out of the classroom."

The remainder of this chapter presents a plan to ease tension surrounding homework for all children and their parents, but it is especially mindful of those students who are the focus of this book. These, of course, are the students who struggle with reading, spelling, handwriting or math difficulties. They are the students who are so fatigued by the time they arrive home from school that becoming emotional or blowing up over homework is only a breath away. Students with learning or behavioral difficulties have it so much tougher than those without these challenges, and consequently, so do their parents. Some down-to-earth advice is presented here, because if we fail to resourcefully manage homework, we should not be surprised when our children avoid it and become experts at sabotaging it.

Developing a plan: structure, routines and expectations

Setting up day-to-day routines and expectations at home are parental responsibilities, and homework has to be included. Those who can generally keep to a routine and find appealing ways to help their children plan and organize, add to their children's capacity to persevere and succeed. Ideally, this way of thinking needs to begin as early as possible. For a number of children, this type of input continues to be vital year after year. Good habits aren't secured simply by managing well for a month or a school term. Unfortunately, the longer parents avoid dealing with homework expectations, the more entrenched their children's bad habits become, and the more resistant the children become to changing their bad habits into good ones.

Challenge yourself:

Have I set up a homework routine for my child?

Does my child know my expectations?

Have I discussed these expectations?

What do I do to maintain a homework routine?

What else could I do?

Do I accept it if my child doesn't do homework assignments?

What are the consequences I have established for when my child forgets or refuses to do homework?

Making a start

For many families, whether or not the children have learning or behavioral difficulties, the following plan is like a breath of fresh air! First and foremost, it involves the most powerful people in a child's life—parents and teachers—in shaping the child's attitudes towards homework. The plan is success based but also provides a straightforward, nonemotional result for not following through on understood homework expectations. This approach is for students of all ages and can be adapted to support specific personalities and needs.

Challenge yourself:

Take a moment to reflect on what might work against your child's ability to deal with homework. Identifying these issues will help you plan more thoughtfully.

Does your child have a poor routine?

Does the child lack practice and good habits?

Does the child plainly oppose homework?

Is the homework usually too difficult for the child?

Are you expecting too much?

Are you expecting too little?

Are you around to support doing homework?

Do you follow up on the homework?

Does your child watch too much television and play too many computer games or have an obsession with phone calls, text messaging or instant messaging on the computer?

Does the child have an inappropriate environment for homework, e.g., poor lighting, unbalanced heating or too much noise?

Are the stationery supplies poorly organized or nonexistent?

Is your child always too busy with friends after school?

Is poor motivation a problem, perhaps due to lack of past success, just plain laziness or other interests?

Does the child experience learning difficulties?

Does the child have difficulties with concentration or impulsivity?

Is your child afraid of getting work wrong?

Does your child have good intentions but keep procrastinating?

Is your child overloaded with too many other activities?

Is your child excessively disorganized and forgetful?

To begin, make time to talk with your child about homework. Try not to be confronting. Instead, suggest that it's a good time for a change, a time for everyone to step up a little. Explain that by inserting a few new routines and a different way to organize homework, things can be better. Also make it clear that the strategy is incentive based, so there is plenty of opportunity for your child to earn rewards not usually available. Equally, the plan calls for a penalty if the child does not follow through on agreed homework expectations.

Pulling new routines together

Times best suited for homework vary from home to home. Start by setting up a homework time for each school day. Most parents encourage their children to unwind and have a snack after school, then tackle the bulk of homework before dinner, leaving the rest of the evening relatively free. It may be necessary to negotiate taping your child's favorite television program, if it conflicts with the homework time. He can then watch it later as an incentive for completing his homework. Set an expectation that homework will have to be completed before the program is viewed at all.

A good way to approach this is to fill in a blank in the *After-School Timetable* that you will find at the end of this chapter. Fill in each half-hour time slot for Monday to Friday. (Most students

are allowed to keep Friday evenings free to relax, and any weekend homework is scheduled for late Sunday afternoon.) Record all regular weekly activities: must-watch TV programs, dance lessons, Cub Scouts, karate and so on. In doing this, children and young teens quickly see that relatively little time is expected for homework compared to the total amount of recreational time they have available. After this exercise is done, it becomes obvious that certain times of each day more naturally lend themselves to homework opportunities. Select the best time for homework for each day, and fill out a new timetable. Color-code homework times and other activities recorded on the timetable.

Place the weekly timetable in a prominent position. This is a wonderful first step, because if a homework time does not exist in a parent's home routine, then why should it exist in the child's routine? Keep the communication open, and adjust the timetable occasionally so it continues to work. Bear in mind that it is unfair to expect an unmotivated student to break old habits and adopt new routines without your resolute support. Surprisingly, the active, ongoing support necessary to maintain new routines is often underestimated by adults, and this can result in the new approach failing fairly quickly. Other times, parents don't even try to change an unworkable situation, despite the fact that it is harmful to the child and creates tension at home. In using the suggestions presented here and being persistent and creative, you can help your child avoid the fates that befell the children in the following examples.

"Why isn't your homework done, Lachlan?"

Ten-year-old Lachlan was identified with Attention Deficit Hyperactivity Disorder and mild learning difficulties several years ago. Each afternoon, he went to after-school care and was picked up by his parents around 6:00 p.m. Each morning as they dropped him off at school, they would ask him to make sure he did his homework at the after-school care program. However, the excitement of being with friends and wanting to join in meant homework was the last thing he thought of during his time there. Besides, doing homework wasn't really a prized practice for the children at after-school care.

When his parents picked him up, they always asked if his homework was done, and of course it never was. From that moment, his relationship with them iced over. They felt irritable, as they knew that after a rushed dinner, they would need to help Lachlan with his homework. By the time dinner was over, it was 7:30, and although he wanted to try, Lachlan was tired and unmotivated. His resources were depleted!

Amazingly, his parents persisted with this totally unworkable homework routine rather than creatively exploring other avenues to better support Lachlan!

No structures for Katrina

Fourteen-year-old Katrina arrived home to an empty house after school. She had been identified as a gifted student with moderate concentration problems. Katrina was always well-intentioned, but she was hampered by her day-dreamy, procrastinating nature. Her good intentions to do homework were always

thwarted by a succession of minor distractions. Feeding the dog, grooming the dog, making a phone call, answering the phone, text messaging on her cell phone, watching television, turning on the electric blankets for her mom and dad, making a snack, looking at a magazine, bringing in the mail and then making another snack peppered away at her commitment to homework. Two hours later, her parents would arrive home. Invariably, they were disappointed with her lack of attempt to do homework, but they allowed Katrina to continue with this consistent failure. By the time she turned 16, she refused to go to school. It was too hard. Success in high school relied heavily on work being completed outside of school hours, and there was too much unstructured time for Katrina to cope.

Make homework time free of electronic entertainment.

The computer can be used for homework, of course, but from very early on, develop an understanding that homework time is free from television, computer games and telephones. For some children, homework requirements pale into insignificance when compared to the entertainment value of various electronic media. This potential conflict needs to be resolved. Homework time needs to exist in its own right. Creating this block of time means homework has a chance to become a genuine part of the family routine. Many families take this a step further, and whether homework is assigned or not, they create a consistent, electronics-free time anyway.

Create a contract.

The homework timetable gains further importance when displayed with a contract signed by your child, yourself and possibly the teacher. This written promise is a visual reminder of the individual steps required to achieve homework success. You might like to use or adapt *My Homework Contract* at the end of this chapter.

Where is the best place to do homework?

Sometimes the kitchen table is best, as parents can hover while they busy themselves with other tasks. This provides parents with the opportunity to watch their child work, help out when asked and develop an understanding of the rhythm of their child's attentiveness and perseverance. In contrast, as students mature, they often appreciate their own space. If this point has been reached, then rework the bedroom or a spare room so it becomes inviting for research, study and homework. A room set up for the purpose of homework can give children a surprising kick start!

Why use incentives?

Incentives are powerful but gentle persuaders. The job of incentives is to help your child stay motivated and stick to the emerging homework habit. When a reward is within reach, children are far more likely to put in that extra effort to obtain a goal. Offer simple, affordable incentives that are enticing! Ideas might include Friday dinner at a fast-food place, a take-out meal that

your child selects, a toy, a book, a video/DVD rental or a movie. Keep the understanding simple. If the homework commitment is kept, then your child receives the reward.

Place one of the homework incentive charts provided at the end of the chapter alongside the homework timetable and contract, and mark off each time a homework period is successful. This will help your child to see where his efforts are taking him as he adapts to the new routine.

Initially, incentives can play an important role. To start with, it may be motivational to offer a small incentive after completing a successful evening and a larger incentive at the end of the week. Over time, the aim is for your child to get used to the new homework routine without the use of incentives. After a period of consistently using this approach, the program can be altered so an incentive is achieved halfway through the term or at the end of the term. However, until children can see the results of their new efforts, incentives are an effective way of consolidating the positive changes you want to create.

If the homework goal is not achieved one evening, it isn't necessary to chastise your child about failure. He has made his choice, and there will be a direct consequence of his poor choice at school the next day. This is where communication with your child's teacher becomes vital. Simply aim at restarting the homework agreement the next day.

Enlist the teacher's support.

Arrange for an interview with your child's teacher, and explain the new homework approach and the support you would like to have. Explain that the new system may appear as if you have stepped back from your child's homework efforts, and this will initially place a responsibility on the teacher to ensure that unfinished homework is completed at school the next day. Rest assured, astute teachers and principals are always supportive of this sort of proposal. They understand that the approach is encouraging your child's independent learning skills.

Your child's teacher is in a unique position to set this process up for success and is likely to offer suggestions to help with homework. Following are a few that are often raised by resourceful teachers.

Use self-bargaining tricks.

As adults, most of us self-bargain, but we spend little time teaching our children how to do this. Countless times you have said to yourself something like, "I'll finish this off, and then I'll get a cup of coffee." This is self-bargaining in its simplest form, and it helps us regulate what needs to be done. Leading the way and showing your children how to develop this skill can be important, or even crucial, to their success. Following is the essence of helping your child to self-bargain. Try this approach.

Let's say your child doesn't feel like doing homework. Remind him that he knows the consequence for not doing it; i.e., he will have to do it at school the next day. This is the time to show him how to self-bargain. The bargain is to do the homework just well enough so it will be accepted by the teacher. It does not have to be perfect. Make a start by structuring the homework task into smaller segments. Try using the *Self-Bargaining Train* at the end of the chapter to design the tasks, breaks and rewards. Once your child uses this system a few times, he will find this style of thinking easier. The bonus is that it can be adapted for so many other things as well.

Music might help persistence.

Playing easy-listening background music seems to help some students remain settled and focused for longer. Perhaps it's not the music but the feeling of being cut off from the rest of the world that allows better focus. Encourage your child to experiment with different music styles, and use what works.

Try an after-school workout.

For children who are overactive, it's surprising how many parents report that vigorous afternoon exercise is a wonderful homework aid. Activities such as swim club, athletics, gymnastics, bike clubs, running clubs and so on are often mentioned. These parents say that after the burst of intense activity, their child becomes calmer and attends more easily to homework.

Use systems developed at school.

More and more schools are organizing opportunities for students to finish their homework the next day at lunchtime. This recognizes the school's responsibility for the homework set by their teachers. This system is called various names, such as Homework Hall, Second Chance Homework and Homework Club, to mention a few. Best results rely on these situations being positive and reliable. A few schools offer an initiative where students have the chance to stay after dismissal to complete their homework, or the bulk of it, before going home. This allows students who wish to complete homework immediately to get it out of the way. It is also supportive of students whose home life does not contribute to their homework success.

If necessary, find a way for homework to be done at school.

Wisely, some teachers organize a structure where students are able to begin the first part of their homework at school. This confirms that they understand it and can do it. Having already made a start makes it easier to follow through at home. Occasionally, students are encouraged to drop a subject or an elective, and in its place, formal homework support is arranged during school.

Brad was a homework avoider.
By eighth grade, Brad had become a habitual homework avoider. As much as his parents helped, offered incentives and threatened, it was a losing battle. In addition, this battle took a heavy emotional toll on the family. Brad's school supported his parents by insisting that Brad report to the detention room each afternoon following dismissal to complete his homework. Brad was utterly unimpressed with this at first, yet several terms later, he revealed it was the first time in his bumpy scholastic career that his homework was out of the way before 5:00 p.m., making his evenings wonderfully free!

"I couldn't do my homework because . . ."
Have a good laugh at the following age-old homework excuses. Do you have any to add?

- I couldn't do homework because my sister hypnotized me. I was in a trance all night.
- I didn't know we had homework. Are you sure we did?
- Dad made us watch a movie last night.
- The light bulb in my room blew out.
- You (the teacher) forgot to hand back my book.
- I left my bag at home (on the bus, in the car, at my friend's, at school . . .).
- I didn't have a pencil (pen, paper, ruler, crayons, eraser . . .).
- We had to go out.
- I was sick. My family was sick and I had to look after them!
- My dog was sick and we spent ages at the vet.
- I couldn't fit it in. We were so busy doing really important things.
- The dog ate it.
- I've lost it, but I'm sure it's somewhere in my room.
- My mom forgot to put it in my bag.
- Mom cleaned up my room and threw it away.

There's more to it than handing out assignment books.
Teachers and parents are quick to give assignment books to students and expect the rest to follow, and for quite a few it does. For others, we know that the assignment book won't help without continual, heavy-duty monitoring. Sometimes instruction and supervision in using it and vigorous parent-teacher contact makes a difference. In a few instances, the system will not work at all for students. Their disorganization may be so profound that the assignment book itself becomes another factor to trip them up. When this is recognized, get creative and invent other memory joggers, such as: faxing, e-mailing, using personal organizers and iPods, mailing work, text messaging, phoning, making a recording to be carried between home and school, leaving messages on the answering machine and placing messages or photos of the homework onto the student's cell phone.

A sign was an easy aid for Lucy.

"I watched my daughter, bending over the table preparing to start her homework. She busied herself setting her belongings up, pushing away the sign she had made. I asked why doing her homework was no longer the problem it used to be. "It's easy now, Mom. When I get home, I put my homework on the table, have a snack, have a drink and just do it," she responded. A few days later, I spoke with her teacher about the change. Apparently, she had given some simple advice to her students. It must have impressed Lucy to such an extent that she immediately went home and made a sign saying, 'Set your homework up here first. Get a snack. Get a drink. NOW do it!' The sign stays permanently at the table as a prompt for Lucy each afternoon."

Using the new homework approach: when it doesn't work

What should you do when your child forgets or refuses to do the homework?

Imagine today is the first day of implementing the new technique. Discussions have taken place to launch the new system. The electronics-free homework time has been negotiated. Agreements have been arranged and signed, incentives and the incentive chart have been planned and the teacher's support has been enlisted.

It's agreed that between 5:00 and 6:00 p.m. is an ideal time for homework on this particular afternoon.

4:45 p.m. It's time for a prompt. As you walk past your child, who is watching his all-time favorite TV program, mention you will be available to help out with homework if he needs you, once the program is finished.

5:00 p.m. The one-hour homework time slot has commenced, so at this point, you are hoping your child will turn off the television.

5:05 p.m. The television remains on, so walk over and calmly turn it off. Let him know you are available to help up to 6:00 p.m., but not after that. Then walk away. The television remains off.

5:30 p.m. Give a short reminder that you remain available for the next 30 minutes.

6:00 p.m. Announce that you are no longer available to help with homework.

At this point, it may turn out that your child begins his homework. That's fine, but you remain unavailable. On the other hand, if he doesn't start his homework, then whatever happens to him tomorrow is a direct result of his poor choice. Resist the temptation to lecture, complain or listen to excuses. Try not to allow an emotionally heated situation to develop. What many

families do at this point is to ensure that television, computer games and perhaps telephone calls as well are not permitted for the remainder of the evening. It's imperative to have this written into the agreement right from the beginning. Set the standard now, and be as consistent as you can from here on in.

The next morning. Contact your child's teacher via the school office, note, assignment book, fax, e-mail, telephone or whatever method is most convenient for the teacher. This is when your previous communication in developing the plan becomes critical.

Using the new homework approach: when it does work

What would the routine be like if your child does do his homework?

4:45 p.m. Time for a prompt: "I'm available to help with your homework in about fifteen minutes."

5:00 p.m. The television is off, and your child has started his homework.

A few points to remember:

- You are available for the agreed upon time. This means your availability is guaranteed.

- Although this will vary according to the age and needs of your child, aim to directly assist him no more than two, five-minute periods during each 30-minute block. Sitting with your child continuously, or almost continuously, reinforces the idea that you think he cannot function as an independent learner. If your child asks for help, the five-minute periods are for questions, explanations, discussion, suggestions and clarification. When the time is up, walk away and allow your child to do his part, that is, to think and put together the ideas discussed. This allows your child to take control of his homework.

- If the homework is incomplete and your child has worked well, allow him to stop. Sign off in the school assignment book, and write a brief note to the teacher so the child is credited for the effort.

- Complete the homework on a positive note. Allow your child to walk to the store or park, watch a favorite television program, play a game in the backyard or play with a friend for a short time.

- Encourage your child to fill in the incentive chart. This reinforces his progress as he begins to take control over a significant part of his school life.

Being available and unavailable

Saying you are "available" or "unavailable" to help with homework is easy to say and is a way of speaking that is nonconfrontational. These words are less likely than some to feed the emotion that can so easily boil over when discussing homework with your child. Being "available" certainly beats shouting out:

> "Where's your homework?!"
> "Show me your homework!"
> "Do your homework *now!*"
> "Why haven't you started your homework?"

Saying that you are "available" or "unavailable" to help with homework delivers the message that you value your child's homework, but more importantly, it says that it is his homework and his concern. As a parent once said, "While I spent so much time worrying about my son's homework, he knew *he* didn't have to."

In conclusion

On the surface, homework seems to be such a simple idea. Yet, for a number of students with learning difficulties, concentration and impulsivity troubles, mood problems or chaotic home lives, the reality is that regular, meaningful homework practice is tricky to achieve. For a few, it's plainly too much. The information in this chapter is intended to be levelheaded guidance to support children and families who are struggling with homework and help them get back on track. I have no doubt that, in most cases, the processes described and suggestions made will be helpful.

In some instances, students will benefit by homework tasks being reduced and modified. However, for a few, the problem is dramatically more chronic. Generally, when students completely relinquish engagement with their homework, they often have also surrendered a number of other constructive aspects of their education and lives. At this point, they hand over management to adults. Their levels of success and opportunities for reengagement will be measured by the willingness of the adults in their lives—educators, health professionals and parents—to communicate, work as a team and fully utilize available resources. Intelligent adult management needs to determine exactly what is at stake and prioritize the available options. Sometimes for these students and their families, the best decision is to do away with homework altogether, either for a while or forever.

after school timetable

name_____

ill in each of the half hour time slots. Record regular
eekly activities: TV programs, dance lessons, scouts
ort, karate and so on. Then, you will see that certain
mes of each day lend themselves more naturally to
omework.

Time	Mon	Tue	Wed	Thurs	Fri	Sat/Sun
4:00 – 4:30						
4:30 – 5:00						
5:00 – 5:30						
5:30 – 6:00						
6:00 – 6:30						
6:30 – 7:00						
7:00 – 7:30						
7:30 – 8:00						
8:00 – 8:30						
8:30 – 9:00						

my homework contract
10 easy homework steps!

1. Unpack my bag. Take out what I need. Set it up on the desk. Take out my timer or stopwatch.

2. Sit down, open my diary and read what I have to do. Then think, "What is easy and what is harder." Make a choice about what to start with.

3. Think, "How long should this first piece of work take?" To help pace my progress I set my timer to how long I think this first part should take. Then I start.

4. If I find something too hard, I leave it out and ask mom or dad for help later on.

5. When the timer beeps I need to ask myself, "Did I get to where I wanted?"

6. Time to take a five minute break. I set my timer to remind me to return.

7. When I return I need to do the next part of my homework. I have to think, "How long should this next piece of work take?" I set my timer to how long I think this part should take.

8. As I finish it's time to ask mom or dad any questions I have. I listen carefully.

9. Once the timer has beeped for the last time I need to finish up and get mom and dad to sign off in my assignment sheet.

10. I pack my homework into my school bag and go and have fun!

my name_____

my signature_____

date_____

name_____

date started_____

Bruno's homework incentive

When I arrive at Bruno's kennel my reward will be

Help Bruno get to his doghouse by coloring in the bones. Color one bone for each day that you complete your homework. When all of the bones are colored you will receive you reward!

name_____

date started_____

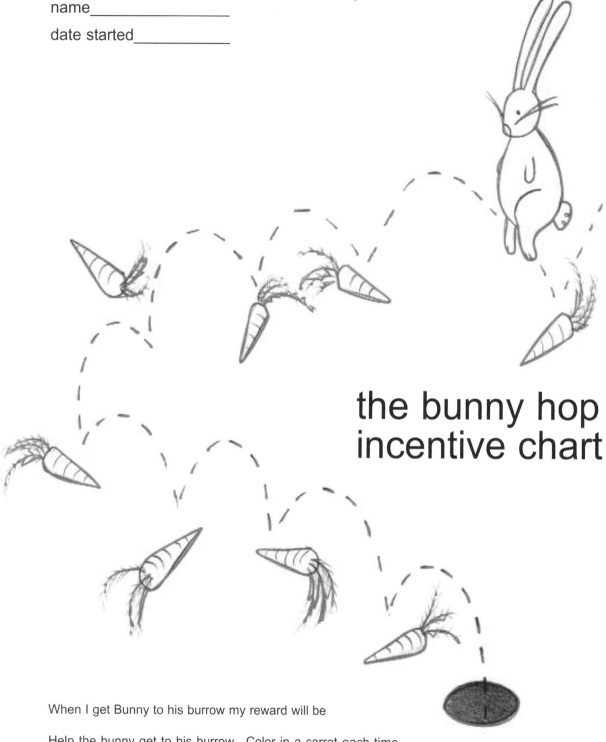

the bunny hop
incentive chart

When I get Bunny to his burrow my reward will be

Help the bunny get to his burrow. Color in a carrot each time
that you complete your homework. When all of the carrots are
colored you will receive your reward.

name_____

date started_____

self-bargaining train

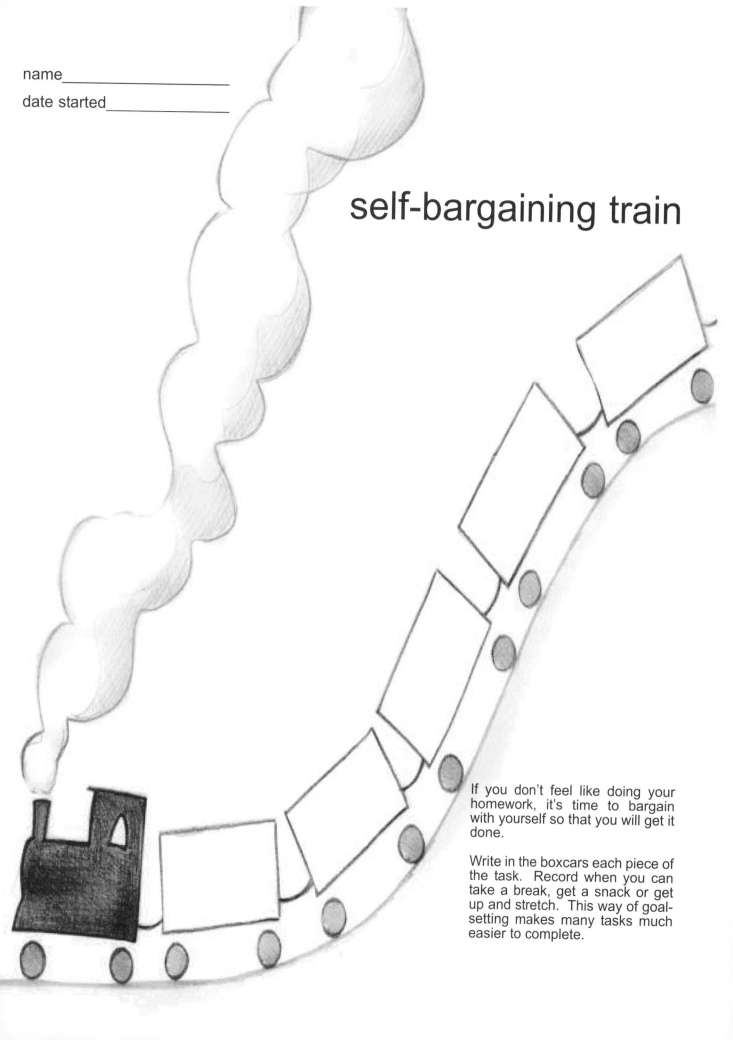

If you don't feel like doing your homework, it's time to bargain with yourself so that you will get it done.

Write in the boxcars each piece of the task. Record when you can take a break, get a snack or get up and stretch. This way of goal-setting makes many tasks much easier to complete.

Chapter 7

How to Build Your Child's Emotional Resilience

What is emotional resilience?

As I have mentioned previously, one of the best ways to secure children's emotional resilience is to focus on normalizing their feelings and helping them to understand their feelings. After all, the way people feel about themselves and the way they interpret their feelings forecast their likely reactions and behaviors. Children's feelings and how they interact with the world have a significant impact on how they handle challenging situations. When faced with a problem, a positive and confident child is likely to react by thinking, "I'm not giving up. Let me try that again." In contrast, a child with tentative or pessimistic qualities might react by thinking, "I'm stupid. I won't ever do that again," or "They shouldn't have done that! I hate them. I'll get them back."

The depth of a child's emotional resilience is reflected by how the child processes and responds to individual feelings. Resilience is often described as durability, emotional toughness or personal flexibility. It allows an individual to reexamine himself, regroup his resources and bounce back despite loss or defeat. It is seen as a measure of a person's capacity to cope, to make sense of difficulties and find constructive ways to turn them to his advantage. Emotional resilience is a prized quality in children, because it positions them for the inevitable challenges they will face in the future.

Tough problems and tough kids

While there are things we can do to help shape resilient attitudes and behaviors in our children, we must also acknowledge that the interplay of emotions is complex and amazingly fluid. Feelings are notoriously fickle things, waxing and waning from one setting to the next. They are triggered by all sorts of antecedents: perfectionism, fear of failure, wanting to impress, wanting to help, feeling unsafe, being confused, too much pressure, inability to relate to a task, past failures, peer influence, parental influence, anxiousness, depression, learning difficulties, relationship issues, learned helplessness and so on. Children, like adults, have sets of feelings that are easily sparked by specific circumstances, which in turn trigger predictable behaviors. These behaviors, of course, can be helpful or problematic.

The children and teens that have been the focus of this book are those with more than their share of habits and behaviors that don't work in their favor. Many of them honestly have a tough time of it all. They forget, don't get around to tasks, get caught up in their own thoughts, think they can't do things, avoid, lose interest, under- or overreact or show demanding behaviors. Sometimes their worrying behaviors are intermittent, sometimes situational and sometimes global. Their poor decision-making skills and poor coping skills impact badly on their basic day-to-day functioning. They start to feel as though their lives were fractured, and they begin to react—sometimes with awful emotion—to any and every little event that comes their way. They look as though they are selfish and thoughtless, and as a result, it is not long before they attract reputations. Their emotional uncertainties can make them look different and keep them excluded.

The results of maturational delays and learning or behavioral difficulties quickly spill from home to school, once schooling begins. Despite wanting to find success at school, their impulsive, anxious or dogmatic natures get in the way of healthy learning patterns and healthy friendship-building. One thing is for certain; each of these children longs for success or to find some sort of acceptance. If you see your child's performance as awkward, difficult, undesirable or impossible, rest assured, he will also be aware of the problems. He will know that his under- or overreaction brings disappointment and criticism from others. Yet, we all want our children to know that their feelings are important, that experiencing a wide range of feelings is healthy and that their feelings matter to us.

Helping children deal with feelings

Following are a few core ideas on how to help children learn to deal with their feelings. In the process, you will raise their emotional resilience.

Act the way you want your child to act.

Children are copycats. The best thing we can do for them is to show them how to handle their feelings by modeling how we handle ours. It is nearly impossible to help children manage their feelings in healthy ways if we do not do this. When we lose our tempers, hit them in frustration, make disparaging comments about others, use our feelings to manipulate or let others manipulate our feelings, our children watch us and learn to do the same. Do what it takes to keep your own emotional life on an even keel. If you are often overwhelmed or off balance, it is difficult for your child to draw a steady source of balanced emotional support.

Talk to yourself.

If you find yourself becoming confused, upset or frustrated as you tackle a task, let your child observe you using 'self-talk.' Let him hear you say, "I know I can get through this. I need to slow down and think about it. First, I'll" This is a perfect way to teach your child how to collect his feelings, stay in control, think and find a solution. According to the research, positive 'self-talkers' are more inclined to persist longer, take healthy risks and find success.

Put feelings into words.

Help your child put his feelings into words from the earliest age possible. Work at expanding his feelings vocabulary. In conversation, freely use words that describe feelings: happy, pleased, satisfied, content, sad, angry, excited, embarrassed, huffy, nervous, anxious, shy, jealous, hateful and so on. Discuss the way people in storybooks, magazine pictures, movies and television sitcoms look and what they are feeling. Talk about how you can tell their feelings. Discuss facial expressions, voice tone and body language. Help your child to socially read between the lines by asking him to guess what might have caused the feelings. Lead your child to suggest the options he has for dealing with such feelings.

In real life, when your child is faced with problems and burdened by emotion, encourage him to figure out exactly what he is feeling. Ask, "Are you feeling sad? " or "Are you feeling angry?" The first step is for your child to work out the feelings. Sometimes writing a basic list or creating drawings showing how he feels can help. Ask, "What happened to make you feel like this?" Such a question may lead to, "I'm sad because Tom and Darren wouldn't play with me." This, in turn, can help to pinpoint why the situation may have happened and what to do next, rather than harboring a grudge and getting back at Tom and Darren the next day. This also provides

the healthy practice of talking about problems and discovering solutions without expecting you to fix them.

Love and listen.

Combining love and listening is truly a highly developed skill. Most of us love our children dearly, and because of this, we frequently do not really listen and give them a chance to talk, sort through their feelings and come up with possible solutions. Instead, our love urges us to fix the problem for them so they can be released from their discomfort. We prematurely jump in with our wisdom and sage advice, or even worse, take on the responsibility for something the child could handle himself and learn from. Work at being a great listener. When your child has something to say, focus on what he is saying, and skillfully reflect back what he has said. This is a wonderful help for children wrestling with intense feelings. Your goal is to help your children process their feelings, not to fix their problems.

Distinguish between genuine and manipulative feelings.

Remember that not all feelings have equal value. It is common for parents to confuse how to respond to their children's genuine feelings with how to respond to their children's manipulative feelings. Just as adults do, sometimes children use their feelings to manipulate a situation. We hear these feelings when they say: "If you loved me you would" "You love her more than me." "If I can't go, I might as well die!" "I have the right to" Manipulative feelings are best ignored or calmly confronted by telling your child you understand that he is upset, but hurting, whining and being emotionally demanding isn't acceptable and will never help. As parents, we need to learn to tell the difference between our children's manipulative feelings and those that are truly genuine. Genuine feelings need to be attended to with love and ingenuity.

Learn the art of acknowledging upset feelings.

Trying to cheer up your child when he is hurting emotionally isn't always helpful. Being upset or unhappy is a genuine human feeling. It is part of life and is experienced by all of us. The most helpful approach is to acknowledge how your child is feeling by recognizing his upset or disappointment. Refrain from saying, "Hey, it's not such a big deal" or "Why get so upset about that?" Children need to know you are there to listen and understand. Their concerns are very real to them.

In practical terms, dealing with children's upset feelings is really an art. On one hand, the more parents tell their children to "get over it," the more their children don't feel listened to and will tend to emotionally shut down or get louder. We all have experienced the empty feeling of being dismissed, and it doesn't feel good! On the other hand, we don't like to see our children in emotional pain. The spontaneous reaction to appease this pain might be to buy them gifts to cheer them up or to spend an excessive amount of time chatting and dissecting the issue. These,

of course, are very poor strategies. They deflect children from learning to use their feelings productively and prevent them from setting up independent patterns of recovery.

Reinforce that sensitive feelings are beautiful.

Help your child to see that all people have feelings and that some experience strong feelings more often than others. Reinforce that being sensitive or having deep feelings is not a failing. Human nature is beautifully uneven, and if there is a failing, it is the inability to find helpful ways to express these feelings. If your child is a sensitive person, use the expression that he "wears his heart on his sleeve." This provides a thoughtful context in which to understand himself and determine what he might do to protect that precious heart at certain times.

Help your child to calm down and talk later.

It seems obvious, but we need to remind ourselves that both children and teenagers are inexperienced, still developing and constantly learning. They have not yet learned to express all of their feelings in appropriate ways, and yet most usually participate in a rich and lively emotional life. Emotional problems are bound to occur. So when your child becomes upset or overwhelmed, try to be a steady, positive influence. Help your child calm down, and as soon as you can, establish a sensible approach that your child can use to calm himself. When feelings are out of control, it is too difficult to discuss problems and way too difficult to think clearly and rationally. Make it a rule never to make your child try. Allow the initial wave of emotion to pass, and when your child has calmed down and his emotions are in check, you can help him deal with the problem.

Teach your child to rehearse.

Planning exactly what to do or how to handle an upcoming event can prevent your child from falling victim to his easily overwhelmed feelings. In situations where disappointment is likely to cause an outburst, try using a rehearsal technique. Rehearsing helps all of us to intellectualize our likely feelings and explore ways to remain calm and look composed. To illustrate this, an elementary student, often overwhelmed by disappointed feelings on presentation evenings at school, helped his teacher write an article for the school newsletter. It explained that while winning a prize on presentation evening acknowledged the efforts of a few, no one could ever take away anyone else's personal best. The process of writing the article for the newsletter assisted him in intellectualizing and dealing aptly with his feelings during the event.

When it comes to fighting the slings and arrows generated by day-to-day living, pass on simple strategies to help your children calm their besieged feelings. For example, as things begin to go wrong, teach your child to press the 'delete key' in his mind to delete the problem. Or, shrink it! By visualizing the problem shrinking into a frail ant or a tiny baby with dirty diapers, your child can reduce the problem to insignificance, allowing him to be a little freer to walk away.

Deal with worries in the daylight.

If your child is a worrier, these key points are worth considering. First, you need to listen to the worries. However, worries are always best listened to in the bright light of daytime rather than in the dark at bedtime. Make it a rule to listen to your child's worries during the day, so that after a reasonable period of participation, the discussion can be brought to a close.

Two favorite ways parents help their children deal with worries are by asking the child to draw a picture of the worries and several ways to deal with them and by using a Worry Box to put away the worry. A Worry Box is a small box with a slot in the lid. For extra security, so the worry won't escape, you might consider a box with a tiny padlock on the lid! Once the worry has been discussed, it is written on a piece of paper, which is then folded up and placed into the box. Now the worry has been dealt with for the day, and no further energy needs to be spent on it. The fascinating part is that when the worries are looked at months later, most children and young teens say, "That worry sounds silly now." This, in itself, delivers a healthy message about how much value we should give to worrying.

Avoid labeling or stereotyping.

Avoid stereotyping children (or anyone) because of their feelings. Comments such as: "He's an angry jerk," "She's a sourpuss," "He's a crybaby," or "Harry the hermit—forget him!" are plainly damaging. Too often, the child will start to believe what is being said, and the stereotype will become a self-fulfilling prophecy. The child has no other choice but to live up to expectation. Lead your children to look beyond labels and think about the invisible feelings below the surface that drive the behavior. Instead of labeling people, teach a more insightful language. For example, "He's got quick feelings and can get angry" or "She's shy and just takes a while to warm up."

Help your child grow through losing.

Currently, it's fashionable to encourage all children to feel as though they are winners rather than allowing them to be exposed to the disappointment of losing. One can't help wincing at the shortsightedness of this popular thinking. I propose that losing is not such a bad thing, and in fact, can be helpful. Through experiencing losing, our children learn:

- that none of us are good at all things, nor are we expected to be.
- that we lose because, at that particular time, we were not good enough, and this is the way of life.
- to appreciate the winner's talent in the context of humanity's amazing diversity.
- that effort and commitment is never diminished.
- how to regroup emotions, bounce back, persist and strive again.
- how good it feels to honestly win or succeed.

- to control feelings by being gracious in the face of defeat or disappointment.

Give some thought to the idea of winning and losing as a lesson to enhance your child's emotional development and to emphasize to your child the ebb and flow of real life.

Connect feeling, thinking and behaving.

Raising our children's emotional resilience does not come from doing or fixing things for them, a New Age cure or months of psychotherapy. The best we can do as parents is to persevere with grounded approaches that guide our children to deal more successfully with feelings. We must use simple approaches that make connections between what is being felt, what is desired and the options that are available to deal with feelings. For a number of children who are the focus of this book, consciously inserting connections between feelings, thinking and behaving must be explicitly taught. To be honest, this simple strategy may prove to be the greatest gift we provide, because engaging children to think is what transforms behavior and sets up successful, resilient lives.

Encouraging independence

One way to bolster your child's confidence and independence is to arrange for the child to prepare a meal for the family once or twice a week. A little support may be required, depending upon the child's age and skill. With help, most eight-year-olds are capable of preparing a simple meal for the family. The underlying importance of this cannot be overstated. Without wishing to upset or lose any of my reading audience, many of the children I see with memory problems, learning difficulties and behavioral immaturities often have their moms at their beck and call. Nudging children to progressively do things themselves and help others encourages them to stretch and gain more independence, and independence supports emotional resilience.

Broaden life experiences.

The next step may be to steer your child to helping others outside of the family. The idea of giving back and doing thoughtful things for others instantly immerses your child in an emotionally broader world. This sort of involvement places the child in a position where he begins to compare his attitudes, life and feelings to those around him. As he experiences and absorbs the thoughts and feelings of others, a more selfless and inclusive view of life is naturally promoted. Ask yourself how long it has been since your child sent a Thank You card, a warm e-mail, a friendly note or a handmade card or called someone who has been helpful or needs a lift. Teaching our children to care about others reinforces the feeling that they, themselves, are genuinely cared for.

You make the difference!

Finally, never underestimate the power of a healthy, loving family. You and I both know there is no such thing as a perfect parent, a perfect child or a perfect family. However, even in the most limiting circumstances, parents who love their children and value their relationship with them can make a big difference. Know that *you* will make the greatest difference for your child: what you think, what you say and what you do. Your greatest contribution will be to trust your intuition and capitalize on the knowledge you have about your children.

Are you ready to challenge yourself?

Start with one small step, and focus on making one optimistic change!

Do it *now!*

References

Armstrong, Kerry. *The Circles.* Melbourne: Hardie Grant Publishing, 2003.

Biddulph, Stephen. *Raising Boys.* Sydney: Finch Publishing, 2003.

Biddulph, Stephen, and Shaaron Biddulph. *More Secrets of Happy Children.* New York: Marlowe & Company, by arrangement with HarperCollins Publishing, 2003.

Carr-Gregg, Michael. *Surviving Year 12.* Sydney: Finch Publishing, 2004.

Coloroso, Barbara. *kids are worth it!* New York: HarperCollins Publishing, 2002.

Fuller, Andrew. *Raising Real People: Creating Resilient Families.* 2nd ed. Camberwell, Victoria: ACER Press, 2002.

Hedley, Darren, and Robyn Young. "Social Comparison and Depression in Thirty-six Children and Adults with a Diagnosis of Asperger Syndrome." *Autiser,* Autumn, 3–4, 2003.

Jensen, Eric P. *Brain Compatible Strategies.* San Diego: The Brain Store, 2004.

Le Messurier, Mark. *Cognitive Behavioral Training: A How-to Guide for Successful Behavior.* Thousand Oaks, CA: Corwin, 2006.

Lillico, Ian. *Homework and the Homework Grid.* 2004. Distributed by Educating for Success Pty Ltd., PO Box 3211, Warner, Qld 4500, Australia. Phone enquiries: 07 3298 5500

Moore, Lorraine O., Ph.D., and Peggy Henrikson. *Creating Balance in Children's Lives: A Natural Approach to Learning and Behavior.* Thousand Oaks, CA: Corwin, 2005.

Petersen, Lindy. *Social Savvy: Help your child fit in with others.* Camberwell, Victoria: ACER Press, 2002.

Petersen, Lindy, with Allyson Adderley. *Stop, Think, Do Social Skills Training: Early Years of Schooling Ages 4–8.* Camberwell, Victoria: ACER Press, 2002.

Petersen, Lindy, and Mark Le Messurier. *Friendship Neighbourhood: STOP and THINK Workbook.* Adelaide: Foundation Studios, 2002.

Rigby, Ken. *A Meta-evaluation of Methods and Approaches to Reducing Bullying in Pre-schools and in Early Primary School in Australia.* Canberra : Commonwealth Attorney-General's Department, 2002. *(www.education.unisa.edu.au/bullying/intervention.htm)*

References

Rigby, Ken. *New Perspectives on Bullying.* London: Jessica Kingsley Publishers Ltd., 2002.

Rigby, Ken, and P.T. Slee. "Suicidal Ideation among Adolescent School Children, Involvement in Bully/Victim Problems and Perceived Low Social Support." *Suicide and Life-threatening Behavior*, 29, 119-130, 1999.

Shore, Kenneth, Psy. D. *Special Kids Problem Solver: Ready-to-Use Interventions for Helping All Students with Academic, Behavioral, and Physical Problems.* San Francisco: Jossey-Bass, 1998.

Strohm, Kate. *Siblings.* Kent Town, South Australia: Wakefield Press, 2002.

West, Peter M. *Fathers, Sons and Lovers.* Sydney: Finch Publishing, 1996.

Wiseman, Rosalind. *Queen Bees and Wannabes: Helping Your Daughter Survive Cliques, Gossip, Boyfriends, and Other Realities of Adolescence.* New York: Three Rivers Press, 2002.